IMAGES
of America

GARY'S
EAST SIDE

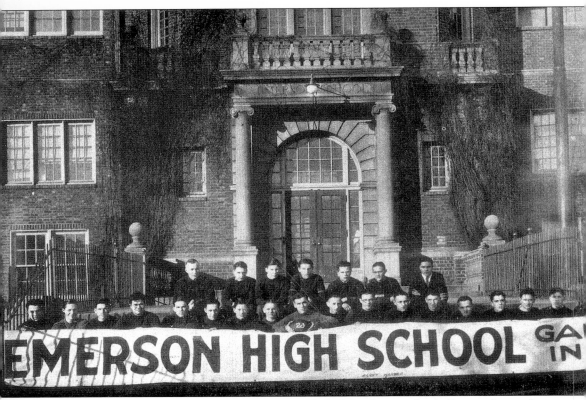

EMERSON FOOTBALL SQUAD, 1923. Emerson High School was a football powerhouse during the 1920s. In the fall of 1923 the Gold and Grey repeated as the State Champion of Indiana and became a team of legend. They outscored their opponents 234 to 0. That team was christened the Golden Tornado by sports writers for their ability to score quickly and often. From that season on, the Emerson football squad proudly carried the title of the Golden Tornado. (Courtesy of Calumet Regional Archives.)

EMERSON LOYALTY

Oh Emerson our school
O'er other schools you'll always rule
We will link your name
With fairness, honor, and with fame
Each one, oh Emerson
Will stand by you till time is done
And still with voices loud and clear
We'll cheer for you Emerson.

IMAGES
of America
GARY'S
EAST SIDE

John C. Trafny

With an Introduction by Stephen G. McShane
Indiana University Northwest

ARCADIA

Published by Arcadia Publishing,
an imprint of Tempus Publishing, Inc.
3047 N. Lincoln Ave., Suite 410
Chicago, IL 60657

Printed in Great Britain.

Library of Congress Catalog Card Number: 2001099795

For all general information contact Arcadia Publishing at:
Telephone 843-853-2070
Fax 843-853-0044
E-Mail sales@arcadiapublishing.com

For customer service and orders:
Toll-Free 1-888-313-2665

Visit us on the internet at http://www.arcadiapublishing.com

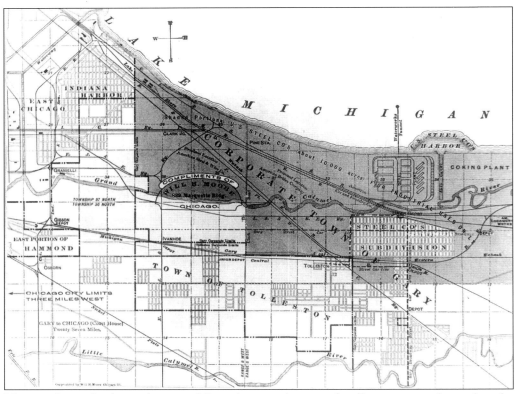

MAP OF GARY. In this early map of Gary the town limits and mill property are located in the shaded area. The East Side neighborhood can be found in the section listed as the Steel Company's Subdivision at the right. (Courtesy of Calumet Regional Archives.)

CONTENTS

ACKNOWLEDGMENTS

Memories of the neighborhoods that we grew up in occupy a special place in our hearts. Those of us who lived on the east side of the city of Gary have fond recollections of the people, places, and events that were an integral part of our lives. At class reunions and social events many of us reminisce about old friends and the places we hung around when out of school. Those great stores along Broadway, the Steel City's main commercial street that we shared with the Horace Mann district, come to mind. We recall our days at school, dances, and sporting events. And, of course, we swap stories about the things we got away with, especially in school.

Those recollections of our youth slowly fade as the years go by. Like the sand dunes along Lake Michigan's lakeshore that shift with the blowing wind, our memories of the way things really were are not exact.

A few of those moments are frozen in time and will never change. Sometimes forgotten, they are tucked away in albums and boxes that sit in drawers or attics. They are pictures, taken long ago, to serve as reminders of who we were and what we did.

Gary's East Side, which covers some 90 years and four generations, is a pictorial history of one of the Steel City's oldest neighborhoods. It is also a book of memories for those who were part of it.

None of this would be possible without the assistance of a number of people.

Stephen G. McShane, archivist of the Calumet Regional Archives of Indiana University, Northwest Campus, was kind to offer his time and assistance to locate many of the old photographs.

Many of the photographs were donated to the Archives by U.S. Steel, Gary Works.

Betty Barrett Ripley, editor of the *Gold to Grey* newsletter, graciously provided the priceless "Emerson Loyalty."

Rev. William Martin, former pastor of St. Monica-St. Luke, shared his personal research on the history of the East Side parish.

The staff of the Catholic Youth Organization office in Merrillville allowed me the use of their sports photos.

Francis B. Kent was very kind to let me use his personal memories of the East Side in my book.

My sister, Diane Trafny-Greenwood, spent a great deal of time on the typing.

Others who provided assistance were Bernice Balicki, Larry Gajewski, Edward Kaminski, Rosemary Malocha, Monsignor John Morales, and John Peck. And, of course, Samantha Gleisten, and Arcadia Publishing for their help and patience.

Of course no historical research can be perfect, and the author assumes full responsibility for any and all errors and omissions herein.

INTRODUCTION

I met John Trafny a few years ago, when he came into the Calumet Regional Archives and requested some slides depicting the building of U.S. Steel's monstrous Gary Works steel mill complex. He planned on using the slides while teaching history at Bishop Noll High School. While he didn't necessarily need the images to teach his classes, he wanted them to help his students to understand that significant history occurred in their own backyard.

Such dedication to interpreting and disseminating Northwest Indiana's history struck a positive chord with me, and I have respected John Trafny ever since. Recently, he conducted much research in the Archives to produce *The Polish Community of Gary*, published by Arcadia last year. In his diligent, professional manner, John's book on Gary's Poles proved to be a much-needed contribution to the historical literature on ethnic life in one of the most industrialized cities in the world. He has continued expanding knowledge of the Steel City of Gary with his latest work, *Gary's East Side*.

The City of Gary, of course, provides a microcosm of life in a major urban area during the twentieth century. Many of the historical trends of the United States appeared in Gary: industrialization, ethnic and racial migration, public education, environmentalism, machine politics, and more. At the same time, however, the Gary experience offered its own unique historical phenomena, captured on film by local photography studios as well as family shutterbugs. John scoured the Archives' collections and also many of those personal family albums, gathering numerous images to tell the story of the colorful, vibrant east side of Gary.

In six chapters, the reader will see the variety of institutions and residents constituting the east side and will, no doubt, enjoy some good memories of life in that neighborhood. Images of schools, churches, businesses, politicians, and industry furnish a visual record of the growth and development of the city, in good times and in bad. Much of the book examines two of the anchors of the area, Emerson School and St. Luke's Church and School. Long-time residents will see some familiar places and perhaps see an old friend or relative. Those of us who never lived on the east side will learn a great deal about the strong fabric of community there, begun in 1906 and continuing to the present day.

John Trafny's ties to the neighborhood are evident, for he not only provides solid historical discourse, but also injects his fondness for the place which nurtured and molded him. Join him as he takes you on a trip to Gary's East Side, helping us to understand and appreciate its history and its people during one of the most fascinating periods in the American experience.

Stephen G. McShane
Calumet Regional Archives
Indiana University Northwest

Memories
OF AN EAST SIDER

It's a good past, as these things go, even if set in an unlikely time and in what some might think an unlikely place. People of every generation tend to look back on their formative years, whatever the circumstances, as the best of times. But anyone who grew up on the East Side of Gary in the years before the Second World War knows that it was not Camelot. Gary probably wasn't much different from, say, Pittsburgh, or Youngstown. In the winter, when the wind blew in off Lake Michigan, Gary was bitter cold, and in the summer, when the sun was high and the air still, it was cruelly hot. At any time of the year the air was foul with smoke and grime drifting down from the steel mills along the lakefront.

None of this was made any more bearable by the Great Depression. With steel production off sharply, many men were idle, or working at some lesser job that barely kept their families fed and clothed. Other men relied on welfare, lining up at relief stations for cartons of staple groceries and second-hand clothing.

As gray and disheartening as this might seem, life in Gary was anything but cheerless in the hard times. What eased the pain and made it possible to get by was the quality of the people. They were not at all a homogeneous people. They represented a great variety of ethnic backgrounds, Anglo-Saxon for the most part but with a generous leavening of Poles and Serbs and Italians and everything in between. Whatever tragedy and turmoil might have colored the past in the countries of their origin was now ancient history. All had the urgent, overriding challenge of survival in a difficult time in common.

Almost no one had much money. For those who were fortunate enough to hold on to a job in the mills, the wages, as I remember, were $5.80 a day. White-collar workers were paid $90 a month, which works out to a bit less. Accordingly, a boy couldn't count on much of an allowance from his parents. We had newspaper routes, we found part-time jobs as gas-station attendants, supermarket stock boys, theater ushers. I worked for a time as a page in the public library, for 25¢ an hour, later in a supermarket for the same wage. So many of us had a little "walking-around money," and a little went quite a way. Cigarettes cost 15¢ for a pack of 20, 2 packs for a quarter. Gasoline was 19¢ a gallon, and was bought not by the tank full but by the dollar's worth.

Even when we were broke, there was always something to do that cost either nothing or very little. A nickel would buy a bus ride to the beach or a ticket to the Saturday matinee at the Family Theater. Another nickel would get you a foaming mug of root beer at the beachfront refreshment stand, or a sack of peanut-butter kisses that would see you through the double feature and the "selected short subjects." Without a nickel, you could hitchhike to the beach or go to the YMCA to swim. Sneaking into the movie house was easy; someone was usually willing to throw open the fire exit in the alley. It cost nothing to organize a softball game or watch a game between teams sponsored by Slick's Laundry or Trainor's Tavern in the Merchant League.

When there was nothing to do or watch, there was philosophical debate on the steps in front of the entrance to Emerson High School, across the street from Ben Rubin's delicatessen and soda fountain. Here, on lazy summer days, we sat and talked about many things. Topics ranged from the relative merits of National League outfielders to such questions as who played the better clarinet, Benny Goodman or Artie Shaw, and did Minnie Talbot grade fairly in Algebra.

By 1939, Europe was caught up in what would become World War II, but I don't remember much talk about that on the school steps, even though Poland had been overrun by German troops and many of us had relatives there. By then, with steel production rising and more money in circulation, interest focused on barbers and tailors. A barber known as "Lockie," who practiced his art in the bank building at Fifth and Broadway, was widely considered to be the best. Not all of us could afford him. Superior Tailors, situated below Eighth Avenue on Broadway, was the popular favorite. Those who had the wherewithal went to Mac and Dewey, a more elegant—and much more expensive—shop a block or two up Broadway. A lot of us settled for something off the peg at H.C. Lytton & Sons or Model Clothiers. What in some instances amounted to an obsession with hair can probably be attributed to the movies; actors of that time were meticulously barbered.

From September to June our lives were focused on the classroom and extracurricular activities at school. Not all of us were aware of it, but the Gary public school system was special, ahead of its time. The work-study-play curriculum devised by the innovative William A. Wirt offered something for everyone. There was a course of study that prepared some of us for higher education (though few expected to find the money for college), shop training that led to jobs in the local mills and factories, home economics courses for girls who expected to marry and settle down to running a household. There were bank and orchestra classes, dramatic productions, a variety of sports, and, for those not athletically inclined, ROTC. Some of us signed up for ROTC because it meant getting a uniform, complete with two shirts. We were even taught some of the social graces, at dance classes in the girls' lower gym. Those of us who actually learned a step or two usually turned out for Friday night dances in that same gym. Some of us just clustered around the phonograph to tap our feet to the music: "Star Dust," "Cross Your Heart," "Maria Elena," "No-Name Jive".

By the time we were 17 or 18—younger in some cases—our social life had shifted from Rubin's delicatessen and Emory Badanish's pharmacy at Seventh and Virginia to more mature venues. There was Trainor's neighborhood tavern on Seventh Avenue, a cheery place to which some of us had been introduced as children on Friday fish nights.

Few among us were musicians. I think of John Shultz, bass, and Phil Swan, trumpet, and Jimmy Weiss, drums. Yet music was an important element in our young lives. It was the time of the big bands, and we bought their records—10 inch, 78 rpm, for 35¢ a copy—and took in their appearances at movie houses in Chicago and Hammond. We read "Downbeat," and we sat around the jukebox at Rubin's figuratively at the feet of Frank Sauline, arguing the merits of soloists and singers. We knew jazz from swing and we scorned the "mickey mouse," "ricky-tick" offerings of the Lawrence Welk and Sammy Kayes.

In 1940 it began to look as though we might actually be climbing up out of the depression. The economic pace was quickening, fueled by the war in Europe, and the country was going back to work. The war seemed a long way off, none of our business.

But all that changed with dramatic suddenness on December 7, 1941, when the Japanese attacked our naval base at Pearl Harbor. We began lining up at the recruiting office and going off in ever-growing numbers to the Army, Navy, and Marine Corp. Every Saturday night, it seemed, there was a party for somebody going into uniform, and often the party took place at the White House, a great barn of a dance hall set down in the strip that divided Highways 12 and 20 east of town. Soon the War Department telegrams began to arrive. "…regret to inform you…"

With the end of the war, we began to trickle back and we tried to pick up the threads of our lives where they had been thrown down in such haste. We went back to work. We married old

girlfriends. We drank a lot—at the Spitfire Pub, run by two former RAF pilots; at the Ton-o-Fun, where Tom Egan, fresh out of Air Corps uniform, held forth; at the Gateway tavern, where Walt Mulloy, an erstwhile Army MP, served boilermakers to men going to and coming from the mills; at the long bar of the Lake Hotel. It didn't work. We were older, more serious, even wiser, and we wanted something better than what our parents had known. Incredibly, the GI Bill brought higher education within our reach, and many of us, who had thought of college as something reserved for the rich, took advantage of it. We became lawyers and doctors, businessmen, teachers, even professors.

Years later, Tom Egan, who had quit tending bar and gone off to Notre Dame and a rewarding career as a sales executive, moved to California and settled down not far from where my wife and I lived. When he died of cancer, we went to the funeral service at St. Charles Boromeo Church. The priest said that he'd called on Tom in the hospital, and asked him if he felt any resentment at being struck down in this way. He said Tom replied, "No, Father. I've been blessed."

I think Tom was right. I think all of us who grew up in that time and place were truly blessed.

Francis B. Kent
Emerson High School,
U.S. Navy Veteran of WWII

One

THE NEIGHBORHOOD

Gary's East Side, located just south of the massive U.S. Steel plant, was a working class community. On days the wind came in from the north, the neighborhood received a fine layer of red dust that was released from the tall open hearth furnace smoke stacks. Like the rest of the Steel City, the area was grimy. Still, it was the place East Siders were proud to call home.

That area east of Broadway, Gary's main commercial and business strip, was a residential neighborhood of decent, well-maintained homes and apartments. Houses were not the elegant structures found in trendy suburbs, but suitable to raise a family. Everything was close and residents could walk anywhere in the neighborhood. Most important, people knew their neighbors. Woe to youngsters who came home after a mischievous afternoon down the street or alley.

FIFTH AND BROADWAY. In the late summer of 1906 the infant steel town of Gary, Indiana, was just being laid out. Dunes, vegetation, and swamps covered the entire area. Author Powell A. Moore described it appropriately, calling it part of Indiana's last frontier. This is the view looking north from Fifth Avenue and Broadway. (Courtesy of Calumet Regional Archives.)

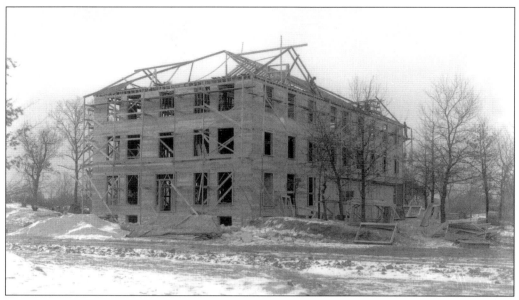

BOARDING HOUSE, 1907. With the building of U.S. Steel's Gary Works well underway, decent shelter had to be put up for the construction crews. Boarding houses were built, as the majority of the workers were single men. Many planned to send for their families when home sites became available. This structure was under construction at Sixth Avenue and Delaware Street in February of 1907. (Courtesy of Calumet Regional Archives.)

GARY LAND COMPANY HOUSE. Many East Siders and people who drove along East Fourth Avenue remember one of the city's oldest structures, the old Gary Land Company building. During the late 1950s and early 1960s, the property was owned by the Gary Historical Society. It sat unoccupied for years but underwent renovation during the 1990s and is now part of Gateway Park. (Courtesy of Calumet Regional Archives.)

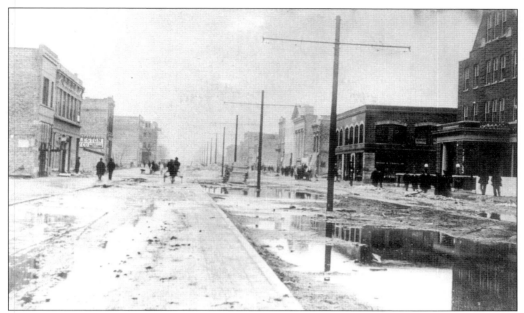

SIXTH AND BROADWAY, 1906. Broadway at Sixth Avenue was in its infancy in 1906. Horse-drawn vehicles were the norm. The tracks for streetcars were just being laid. At right is the original Hotel Gary. (Courtesy of Calumet Regional Archives.)

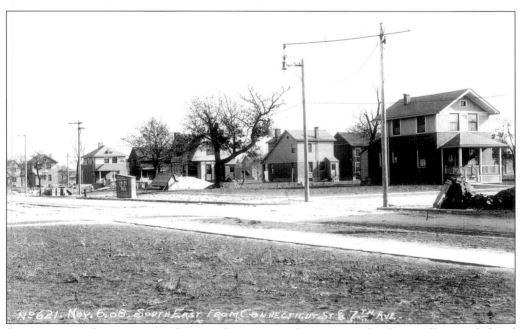

SEVENTH AND CONNECTICUT STREET, SOUTHEAST CORNER. As the Gary mill expanded and workers brought their families, permanent housing went up throughout the East Side. Lots were sold by the Gary Land Company that usually measured 40 by 125 feet. This view is of the southeast corner of Seventh Avenue and Connecticut Street in the fall of 1908. (Courtesy of Calumet Regional Archives.)

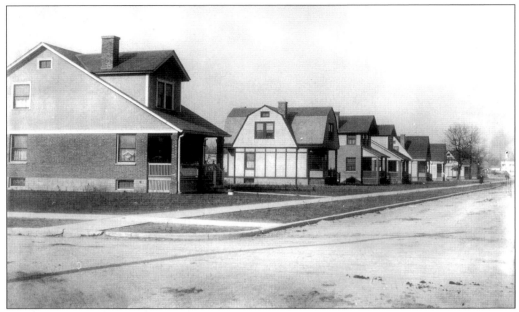

SEVENTH AND CONNECTICUT STREET. When the city of Gary was planned, the streets were laid out in a grid fashion. East-West routes followed numbers beginning at the U.S. Steel property. North-South routes also followed a simple pattern. Those east of Broadway were named after the states as they entered the Union. West of the city's main street, the roads were named in order of the presidents, then justices of the Supreme Court. Pictured are homes in the 700 block of Connecticut Street in 1908. (Courtesy of Calumet Regional Archives.)

DWELLING, FIFTH AND CONNECTICUT STREET. As the East Side grew, a variety of dwellings became available to residents. Apartments went up alongside single-family homes throughout the neighborhood. This 1917 photograph gives an idea of what was available to working families in the 500 block of Connecticut Street. (Courtesy of Calumet Regional Archives.)

HOUSE, 750 DELAWARE. Styles of homes differed throughout the East Side. The house at 750 Delaware, constructed before 1920, provided plenty of yard space but the interior of the dwelling was quite small. For a young family just starting out the place was probably adequate. (Courtesy of Calumet Regional Archives.)

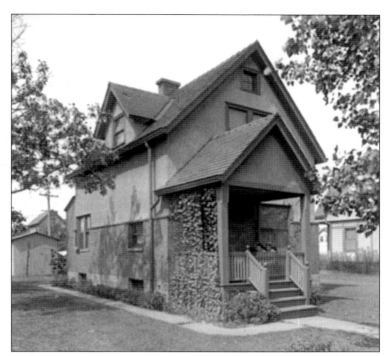

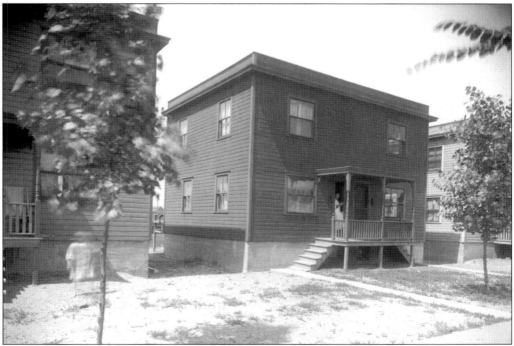

DUPLEX, 564 RHODE ISLAND. Residential dwellings were not limited to apartments and single-family homes on the east side. Row houses were not constructed but a number of duplex type structures were common. This two-family structure was found at 564 Rhode Island Street around the time of World War I. (Courtesy of Calumet Regional Archives.)

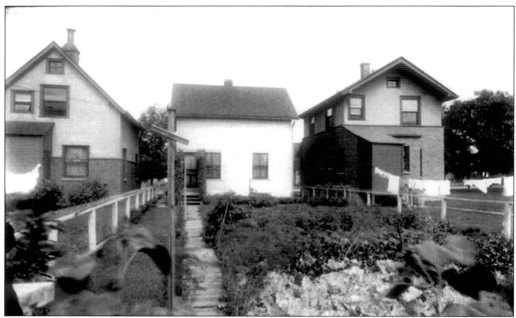

BACKYARD, 700 MARYLAND STREET. East Side homeowners took great pride in their backyard vegetable gardens. Lots were large enough for a variety of crops. Since clothes dryers were unavailable, women hung the wash outside, when the weather cooperated. If there was a northwest wind the smoke from the open hearth furnaces would often cover the laundry with red dust. (Courtesy of Calumet Regional Archives.)

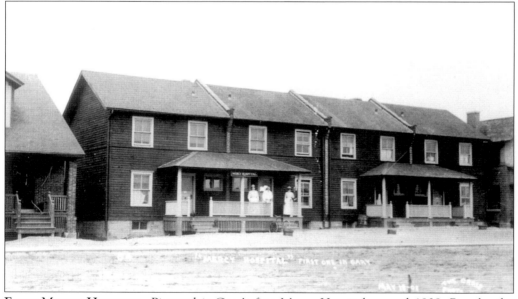

FIRST MERCY HOSPITAL. Pictured is Gary's first Mercy Hospital around 1908. Run by the Franciscan Sisters, the facility was located at Seventh Avenue and Carolina Street across from Emerson School. A few years later a larger hospital was constructed on the city's west side. (Courtesy of Calumet Regional Archives.)

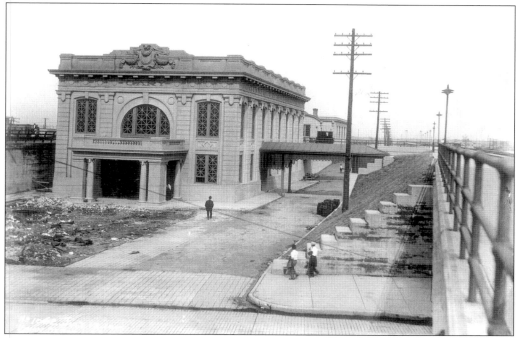

B&O TRAIN STATION. Before the era of air travel, the fastest way to get to ones destination was by rail. Gary was linked to the rest of the nation by a number of railroad lines. Pictured is the Baltimore and Ohio Railroad Station at Third and Broadway. Today the structure stands abandoned and neglected. (Courtesy of Calumet Regional Archives.)

ORIGINAL PRESBYTERIAN CHURCH, 1920. Many houses of worship were built during Gary's early days to meet the spiritual needs of the city's diverse religious population. This photograph is of the original East Side United Presbyterian church under construction before 1920. J.J. Verplank was the architect. (Courtesy of Calumet Regional Archives.)

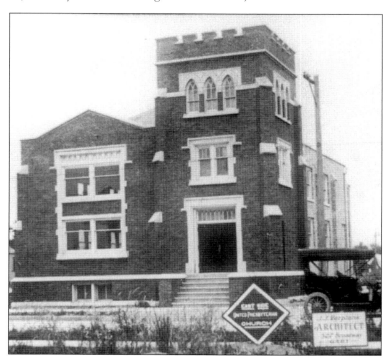

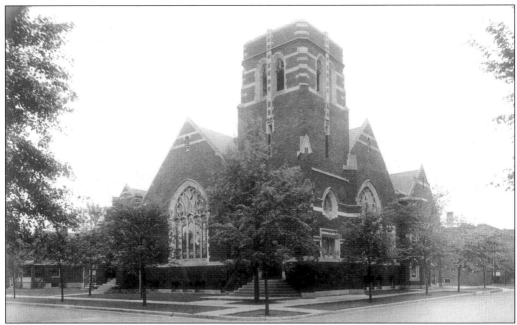

PRESBYTERIAN CHURCH, 1940. A newer and larger First Presbyterian Church stood along East Seventh Avenue in 1940 when this photograph was taken. The impressive and stately structure stood across the street from Buffington Park. Sadly today, only memories and a vacant lot remain. (Courtesy of Calumet Regional Archives.)

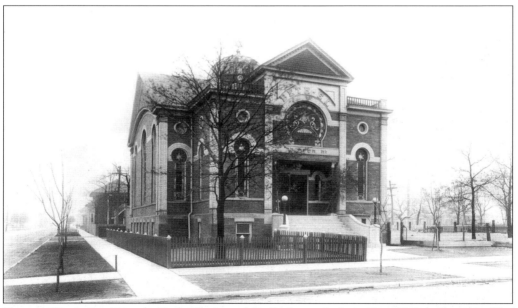

TEMPLE BETH-EL. Temple Beth-El was originally located along East Eighth Avenue. The impressive synagogue saw to the spiritual needs of the neighborhood's Jewish congregation. Today the newer temple is part of the Steel City's Miller neighborhood. (Courtesy of Calumet Regional Archives.)

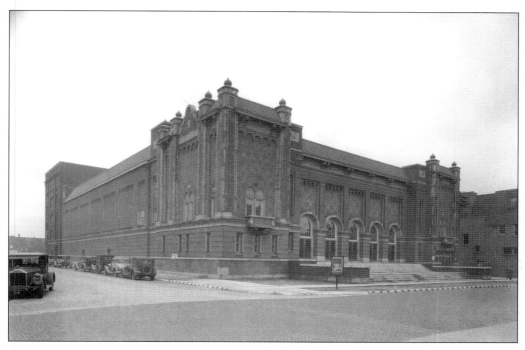

MEMORIAL AUDITORIUM, PAST AND PRESENT. Gary's Memorial Auditorium stood at the intersection of Seventh Avenue and Massachusetts Street since 1927. Concerts, plays, school commencements, and basketball games took place at the venerable structure until the 1970s. Only the north facade remains standing today (below). (Courtesy of Calumet Regional Archives.)

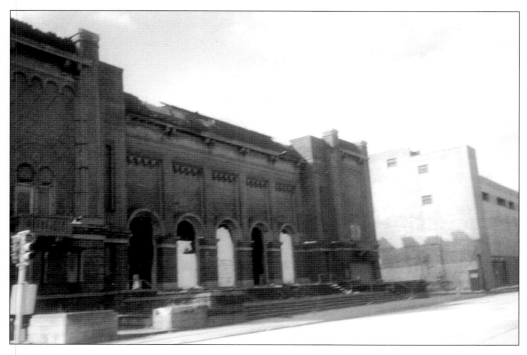

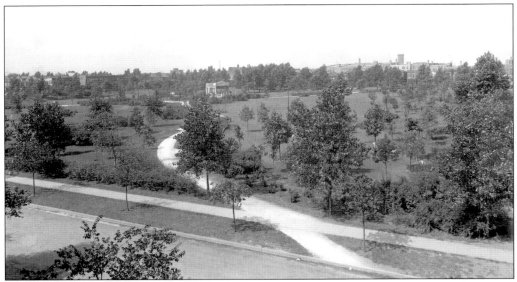

EAST SIDE PARK. When the city of Gary was laid out, specific areas were set-aside in residential neighborhoods for parks. Residents of the Emerson community were able to relax and enjoy themselves at East Side Park along Seventh Avenue. Visible at the center is the pavilion. The park was later renamed for U.S. Steel executive Eugene Buffington. (Courtesy of Calumet Regional Archives.)

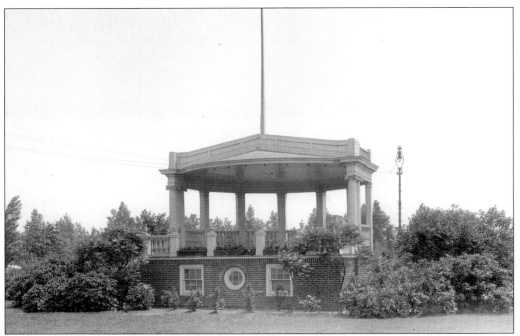

PARK BAND SHELL. At the center of Buffington Park was a band shell. Before the days of TV, videos, and radio, families would go to the park on Sundays and holidays and listen to local bands. Relaxation was important to East Side residents after a hard week at the mills. The park's band shell is pictured in July of 1921. (Courtesy of Calumet Regional Archives.)

PARK MAP. A topographical map of East Side (Buffington) Park that was made for the city's Board of Park Commissioners in 1921. The circle at center was the location of that park's pavilion.

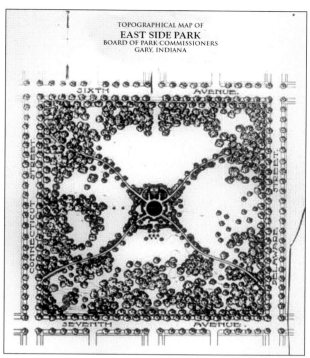

TOPOGRAPHICAL MAP OF
EAST SIDE PARK
BOARD OF PARK COMMISSIONERS
GARY, INDIANA

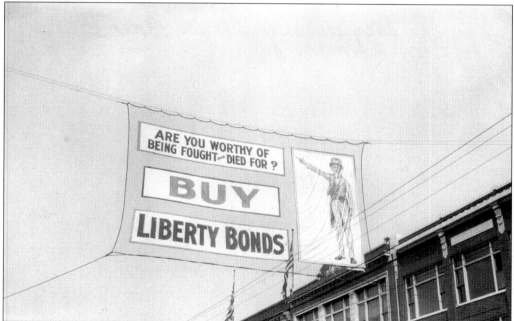

PATRIOTIC BANNER. While American Doughboys from Gary's East Side fought in the trenches of the Western Front, civilians on the home front did their part to help the war effort. To raise money, war bonds were sold to finance America's effort in the Great War of 1917-1918. Here a patriotic banner hangs across the 600 block of Broadway calling for renewed sacrifice. (Courtesy of Calumet Regional Archives.)

BUFFINGTON PARK MONUMENT. Along the north side of Buffington Park sits a simple monument that was dedicated to the East Side veterans of World War II. The names of the former servicemen and women are engraved in stone. Neglected for many years, the memorial structure was cleaned and restored in the late 1990s. (Courtesy of John Trafny.)

GARY THEATER. The Gary Theater, located on the 400 block of Broadway was a civic icon for many years. Plays, films, concerts, and vaudeville acts drew crowds. With the advent of modern movie houses and TV, the building was put to different use. It still stands today and is occupied by numerous offices. (Courtesy of Calumet Regional Archives.)

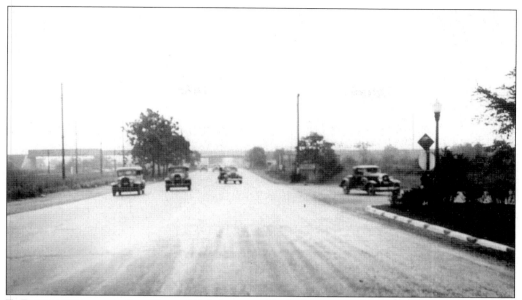

E. Dunes Highway. East Dunes Highway near Sixth Avenue and Indiana Street, now Martin Luther King Drive, had little residential development in 1936. By the 1940s and early 1950s, the area to the right was filled with single-family homes. In the background is the Indiana Harbor Belt Line Railroad, or the high-line, that bordered the East Side neighborhood. (Courtesy of Calumet Regional Archives.)

United Brethren Church. Every Sunday morning, religious music would grace the East Side neighborhood at 9:00 a.m. The Evangelical United Brethren Church at 765 Rhode Island Street would remind the faithful that worship services were underway. Today the church is home to the Central United Methodist congregation. (Courtesy of John Trafny.)

FULL GOSPEL TABERNACLE CHURCH. At one time the Gary Full Gospel Tabernacle Church called 800 Connecticut home. Today it is one of a few structures that remains in the neighborhood. About a half block south, the Habitat for Humanity organization constructed the first residential homes in the area in over a generation. (Courtesy of John Trafny.)

VETERANS BUILDING. To assist the men and women who served in the nation's Armed Forces, the Federal Government built a Veteran's Administration building at Fifth Avenue and Pennsylvania Street. The structure was abandoned in the 1970s. Today it is an apartment building. (Courtesy of Calumet Regional Archives.)

24

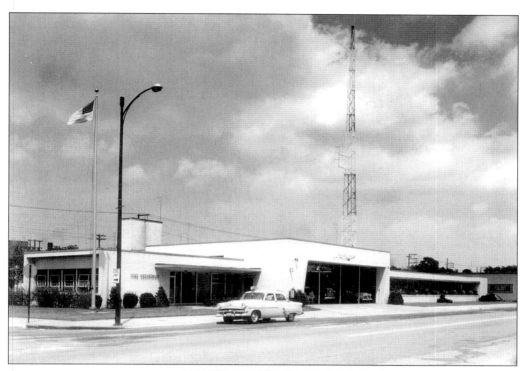

MAIN FIRE STATION. Pictured is Gary's main fire station on Fifth Avenue and Connecticut Street in the late-1950s. Back then Fifth Avenue was still a thoroughfare open to two-way traffic. (Courtesy of Calumet Regional Archives.)

SOLDIERS AT COMMERCIAL BUILDING. During the Great Steel Strike of 1919, strikebreakers were brought in by U.S. Steel to break the union. Violent confrontations took place. Federal troops, under General Leonard Wood, were brought in to restore order. However, private homes were also raided. Troops were housed in the Commercial Club at 615 Broadway. (Courtesy of Calumet Regional Archives.)

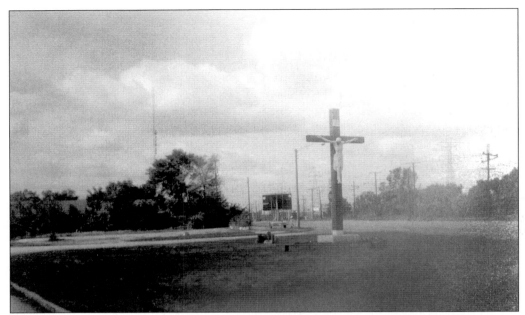

CROSS AT KING DRIVE. Still standing at the intersection of Martin Luther King Drive, formerly Indiana Street, and Dunes Highway is a neighborhood landmark. The cross with the figure of the crucified Christ, put up in the 1950s, protects the countless drivers who pass each day. (Courtesy of John Trafny.)

SIXTH AVENUE AND CONNECTICUT STREET. Two-story homes and apartment buildings were common throughout the east side. Single-family, one-story dwellings were generally found east of Tennessee Street. This view is of Sixth Avenue and Connecticut Street looking north in the late 1940s. (Courtesy of Calumet Regional Archives.)

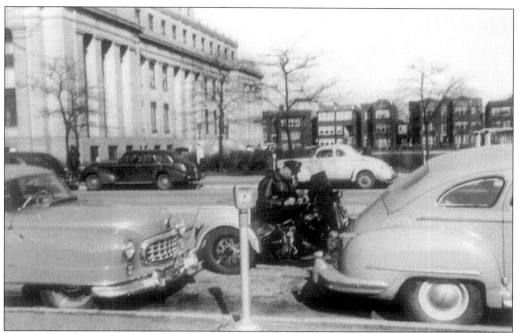

TRAFFIC COP AT BROADWAY. With the Second World War over, Gary citizens were able to purchase automobiles in greater numbers. Feeding the parking meters would take some getting used to. Here one of the Steel City's finest is seen writing one of those dreaded parking tickets across the street from City Hall in 1946. (Courtesy of Calumet Regional Archives.)

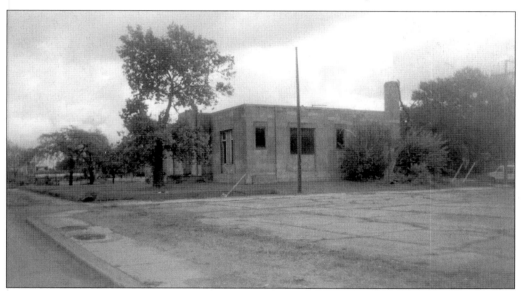

EAST SIDE LIBRARY. A sad reminder of the urban decay that plagued the Emerson neighborhood is the old East Side Library. For generations the local librarians assisted students in assignments, finding resources for term papers, and locating the right book for a class report. The structure has sat abandoned and neglected for years. This photo was taken in October of 2001. (Courtesy of John Trafny.)

AMERICAN LEGION. American Legion Post 17 for many years occupied the building at the northeast corner of Massachusetts Street. Today the structure serves as home to the local firefighters union. The photograph was taken in October of 2001. (Courtesy of John Trafny.)

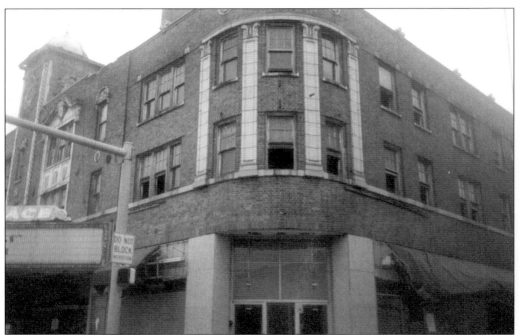

OLD PALACE THEATER. Little is left of the old Palace Theater at Eighth Avenue and Broadway today. At one time it was one of the region's premier structures. Inside, grand staircases took the patrons to upper levels. Beautiful statues were set throughout. Inside the movie area, the ceiling was made to look like the courtyard of a European palace. Abandoned and neglected, only memories remain. (Courtesy of John Trafny.)

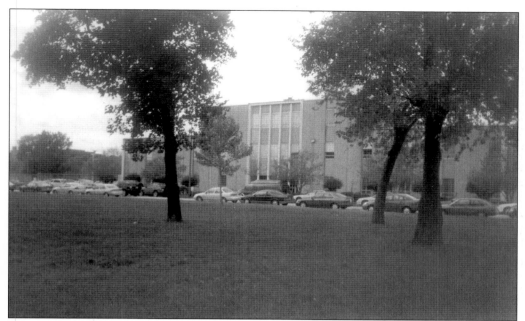

DRAFT BOARD. At one time most offices of the federal government were located at Sixth Avenue and Connecticut Street across the street from Buffington Park. Local Draft Board No. 44 was housed there in the late 1960s and early 1970s. For many young men of the East Side it served as the departure point for the Induction Center in Chicago and military service. This photograph shows the site in October of 2001. (Courtesy of John Trafny.)

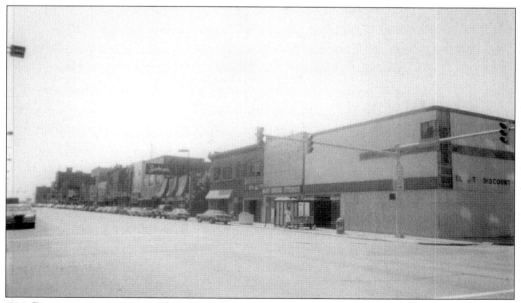

600 BROADWAY, 1990. By the 1990s Downtown Gary became a virtual ghost town. Only a handful of stores continued to operate in the once thriving business district. Jackson's Optometrists was still located on the 600 block of Broadway. (Courtesy of Calumet Regional Archives.)

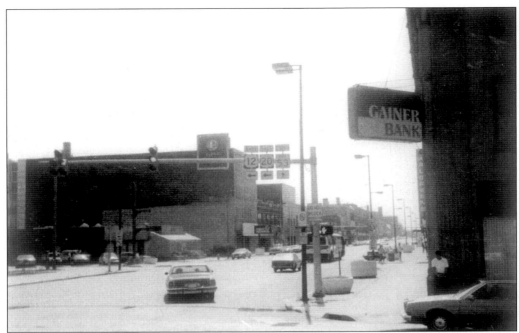

GAINER BANK. Though Gainer Bank, now Bank One, moved to Merrillville, the old downtown financial institution continued as a branch office. (Calumet Regional Archives.)

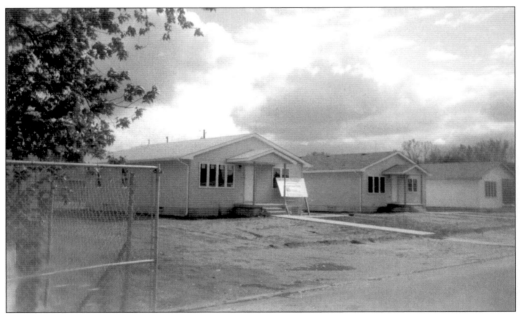

HABITAT HOUSING. Many of the vacant and abandoned homes in the Emerson neighborhood have been torn down. Countless vacant lots now dot the area. But in 2001 the first residential homes in some 50 years were constructed. Habitat for Humanity began a project to build 10 new homes. Three are pictured here in the 800 block of Connecticut Street. (Courtesy of John Trafny.)

BEACH BATH HOUSE. The sounds of summers long ago are just distant memories today. Years ago East Siders enjoyed many lazy summer days at the beach near the old bathhouse in Miller. Neglected for many years, the memorable place has undergone extensive renovation since this picture was taken in the mid-1990s. Now called the Aquatorium, the building's restoration is being financed through public and private donations. (Courtesy of John Trafny.)

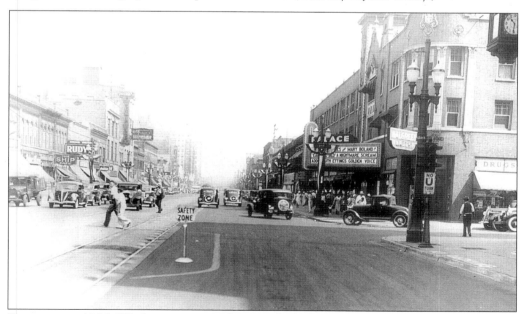

DOWNTOWN 1936. While summertime shoppers flocked to the Steel City's downtown seeking bargains in 1936, others lined up for an early movie at the Palace Theater. The area was still in the Depression but most local businesses continued operations. At center is a safety zone where riders boarded the streetcars. (Courtesy of Calumet Regional Archives.)

MARQUETTE PAVILION. Every summer the beaches at Marquette Park, Lake Street, and Wells Street provided East Siders a place to relax and have fun. The Pavilion at Marquette Park was a place for special occasions for Emerson. Proms, Turn-a-bouts, ROTC Military Balls, and special dinners were held there. In the early 1990s the elegant structure underwent a restoration and is still in use today. (Courtesy of Calumet Regional Archives.)

Two

INDUSTRY

It was U.S. Steel Corp. that attracted potential workers seeking employment to a young Gary, Indiana. Conditions were grueling, 12 hours a day, 6 days a week in a hot, dirty, and dangerous environment. For the swing shift it was a 24 hour day. The 1920s brought improved conditions with better wages and an 8 hour day. By the late 1930s, steelmen finally achieved recognition of their union by U.S. Steel.

Gary's East Side became home to many skilled craftsmen and foremen. Young men could earn a good living for themselves and a growing family. Those not employed at the Big Mill found job openings at other steel-related firms such as Standard Steel Spring, Zweig, and Union Drawn Steel. Others sought industrial opportunities at Gary Screw and Bolt and Certified Cement.

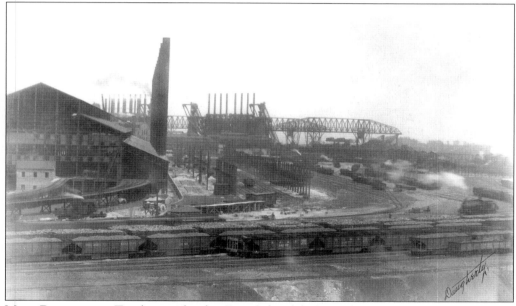

MILL PANORAMA. To the north, the East Side's lakefront skyline was far different from neighboring Chicago. Instead of skyscrapers, towering blast furnaces produced tons of iron 24 hours a day. Open hearth furnaces made steel ingots while huge smokestacks bellowed thick red smoke. East Siders toiled there to make steel for rails, autos, bridges, and the beams that made many of Chicago's office towers. The neighborhoods northern skyline served as a tribute to those who produced American steel. (Courtesy of Calumet Regional Archives.)

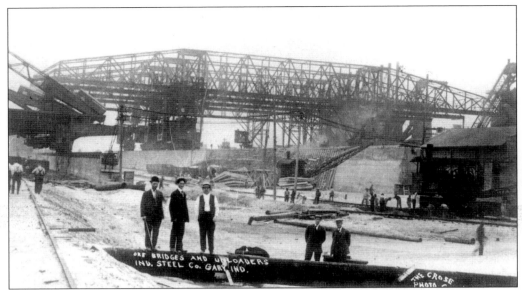

ORE BRIDGE. Since the massive U.S. Steel Works were within walking distance of Gary's East Side, residents had a bird's-eye view of the awesome structures there. The huge bridges were used to move iron ore, limestone, and other materials from storage bins to the blast furnaces. The bridges moved north and south along special rails. This photograph was taken around 1908. (Courtesy of Calumet Regional Archives.)

VIRGINIA STREET GATE. Everyday during the shift change, East Siders who were employed at U.S. Steel's blast furnace or open hearth departments used the Virginia Street gate. Employees walked to work or took the streetcar. On the way home many first stopped at the local watering hole to "wash the dirt down." Pictured is the Virginia Street gate looking south in June of 1917. (Courtesy of Calumet Regional Archives.)

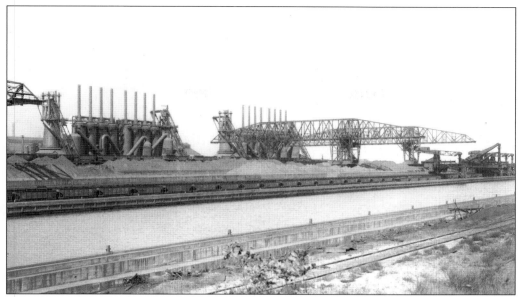

MILL PANORAMA. Before the mid-1920s, East Siders and their fellow men of steel toiled long hours in the mills. It was dirty and often dangerous. But it put a roof over their families' heads and food on the table. The mill also kept the economy of the city of Gary running. (Courtesy of Calumet Regional Archives.)

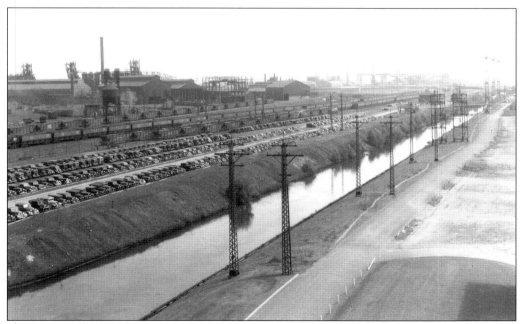

OPEN HEARTH, 1917. When red smoke filled the north sky, East Siders knew the mills were making steel. Huge open hearth furnaces were taking iron from the blast furnaces and making steel ingots. Pictured are the towering smoke stacks of the open hearth department from the south side of the Grand Calumet River in November of 1917. (Courtesy of Calumet Regional Archives.)

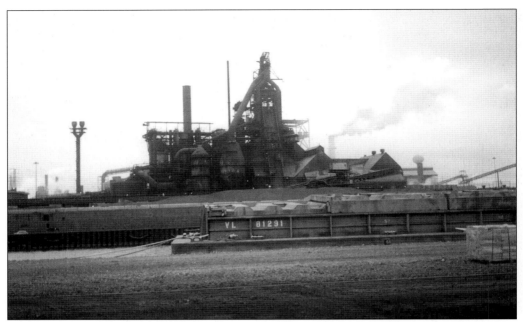

NUMBER 13. Today, Number 13 Blast Furnace dominates the northern skyline of the East Side. Seen for miles, the furnace is one of the largest in the Western Hemisphere. The structure, and the Gary Works, were used in the recent movie *Pearl Harbor*. (Courtesy of Calumet Regional Archives.)

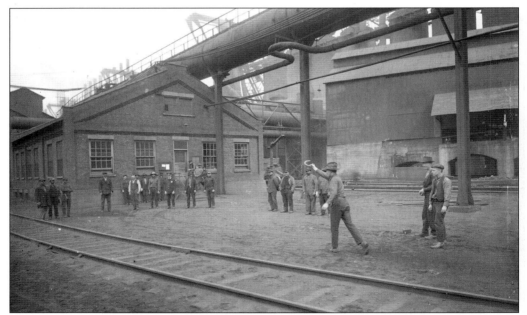

HORSESHOE PITCHING. Work on the blast furnace line was tough, dangerous, and dirty. Yet sometimes there were a few moments to relax. Here a group of blast furnace workers take some time to pitch horseshoes during their lunch break in November of 1920. (Courtesy of Calumet Regional Archives.)

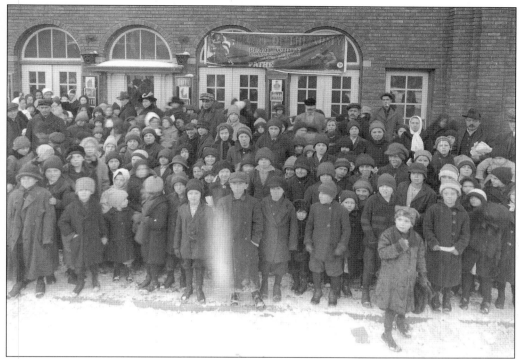

GOODFELLOW CLUB. Many East Side steelworkers were members of U.S. Steel's Goodfellow Club. The organization helped many local families during the years and provided gifts and entertainment for children during the Christmas holidays. In this 1916 photo, children wait outside a local theater to enjoy a Goodfellow presentation. (Courtesy of Calumet Regional Archives.)

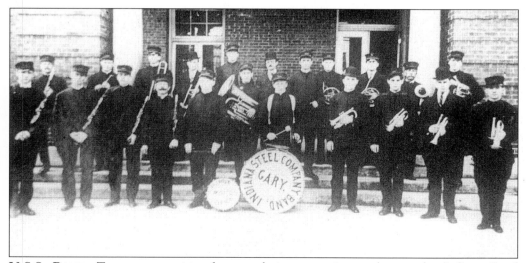

U.S.S. BAND. To create a spirit of camaraderie among its employees, the Indiana Steel Company, later known as U.S. Steel, encouraged participation in after work activities. A number of clubs and organizations were sponsored by the steel giant. Here, members of the company band pose for a group picture around 1910. (Courtesy of Calumet Regional Archives.)

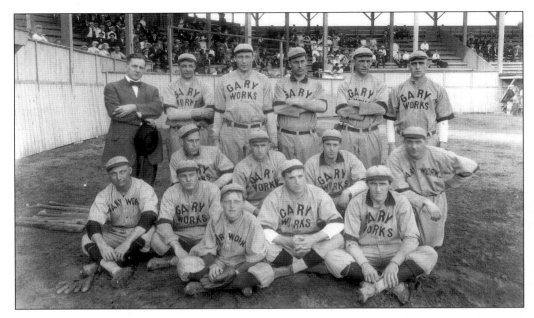

MILL BASEBALL TEAM. Sports provided employees with a temporary escape from the long and dirty hours of steel making. Each department fielded its own team that competed with clubs from other plant divisions. Families and workers who did not play supported their teams by attending games at Gleason Field. (Courtesy of Calumet Regional Archives.)

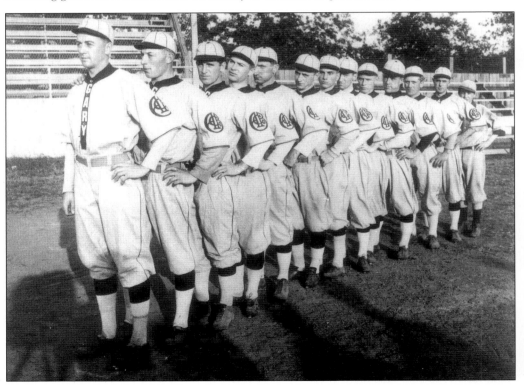

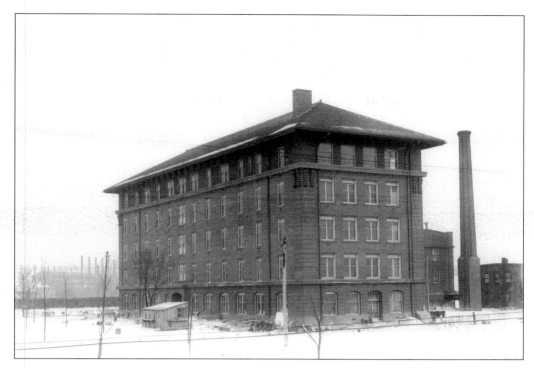

HOSPITAL AND NURSE. Steel making is a dangerous process with workers always at risk of injury. In 1909, U.S. Steel constructed its own hospital east of Broadway to provide employees with immediate care. After Gary's Methodist and Mercy Hospitals expanded the company hospital was phased out. Today the structure serves as a dispensary and medical office building. Below, one of the company nurses before 1920. (Courtesy of Calumet Regional Archives.)

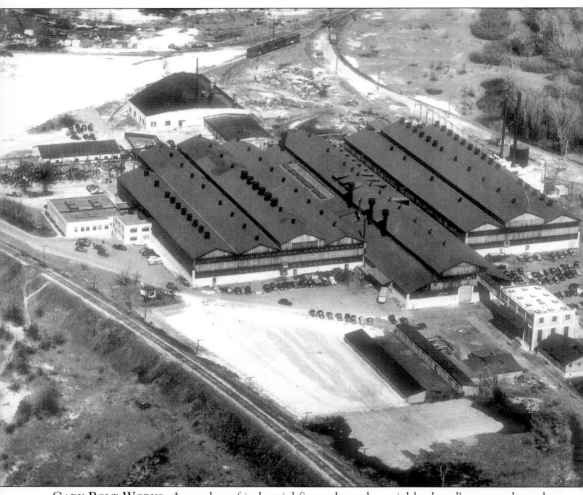

GARY BOLT WORKS. A number of industrial firms along the neighborhood's eastern boundary provided employment for many East Siders. Pictured is an aerial view of the old Screw and Bolt Plant from about 1940. The old Indiana Harbor-Belt High-line can be seen at the lower left. (Courtesy of Calumet Regional Archives.)

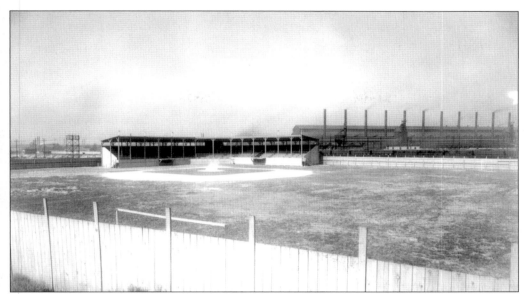

GLEASON FIELD. For years Gleason Field played host to steel company and school athletic events. Emerson High School played its home football and baseball games there. The field was torn down before World War II to expand the parking lot. (Courtesy of Calumet Regional Archives.)

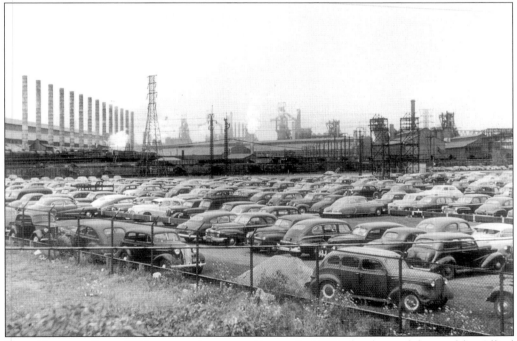

EAST PARKING LOT. With war raging across Europe in 1940, the demand for steel by Allied nations increased greatly. East Siders would benefit from the boom as the need for war materials grew. The view is from the east parking lot looking north towards the open hearth and blast furnace departments. Gone was old Gleason Field. (Courtesy of Calumet Regional Archives.)

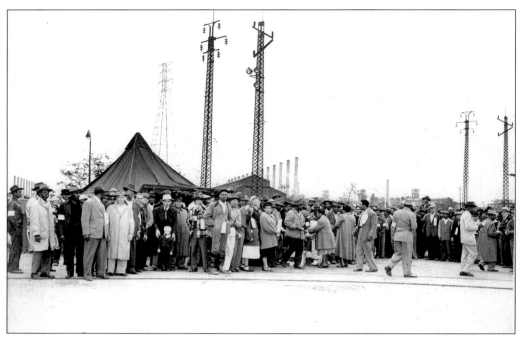

1949 Strike and 1952 Strike. In 1949 the United Steelworkers of America called a strike demanding increased wages and benefits to keep pace with the higher post-war cost of living. Above, strikers gather with their families in the east parking lot outside the main gate. With the three-year contract up in 1952, steelworkers rally once again to demand a better package (below). (Courtesy of Calumet Regional Archives.)

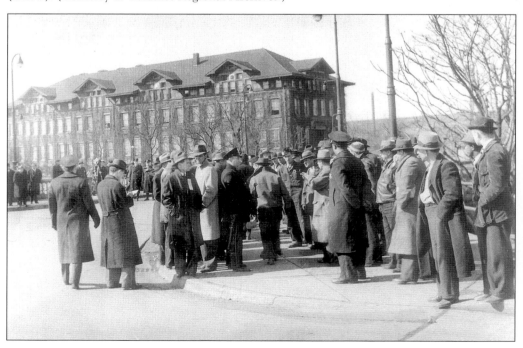

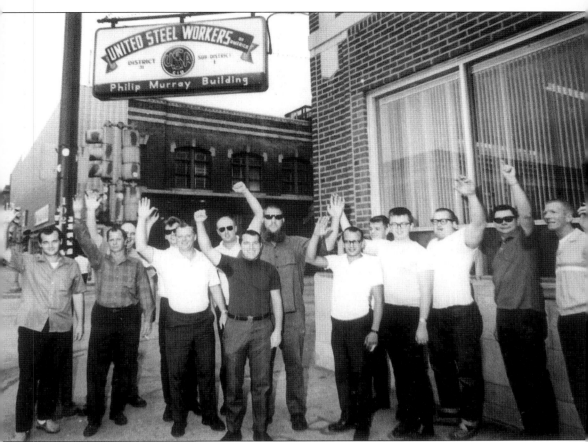

1959 STRIKE. With time running out on the old steel contract, United Steelworkers of America prepared for a walkout. Members of Local 1014 met at the Philip Murray Building at Fifth Avenue and Massachusetts Street to plan a strategy. Pictured are members of the local in 1959. (Courtesy of Calumet Regional Archives.)

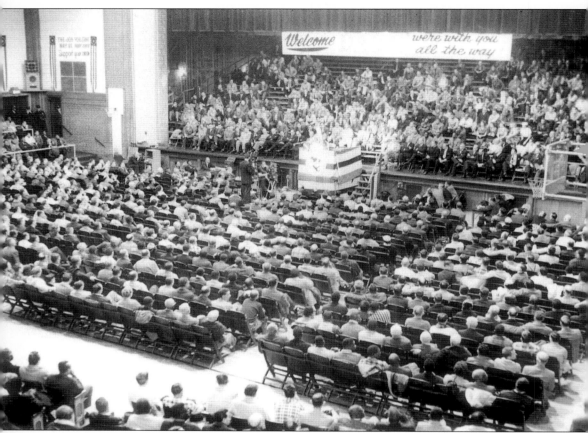

1959 STEEL RALLY. David McDonald paid a visit to Gary to rally the union membership in 1959. Steelworkers from throughout the Calumet Region came to Memorial Auditorium to display their solidarity. The strike lasted 114 days. For many steelworkers, the '59 Strike was also a long "honey do" vacation. (Courtesy of Calumet Regional Archives.)

Three

BUSINESS

Before the population shifted south to the suburbs, Gary's East Side was home to a variety of commercial ventures. Businesses ranged from national chains down to the corner Mom and Pop stores. Broadway was home to Sears, J.C. Penny, H. Gordon and Sons, and Goldblatts. Other establishments included Lytton's, Radigan Bros., and Pearsons. Gary National was the city's main financial institution.

Along East Fifth Avenue Robert Hall provided quality clothes for any occasion while a number of car dealerships had just the right vehicle to get the buyer to his destination. Slick's Laundry and Cleaners, Sno-White Bakery, and Kolaricks Hardware also lined the avenue. In other parts of the neighborhood Jack's Barbershop, Vel's Drugs, Steve's Grocery, and Mike's Superette saw to the needs of their clientele. Finally, local watering holes such as Cozy Corner, Virginia Tap, and Trainor's were there to help working men relax and wash down the mill dust.

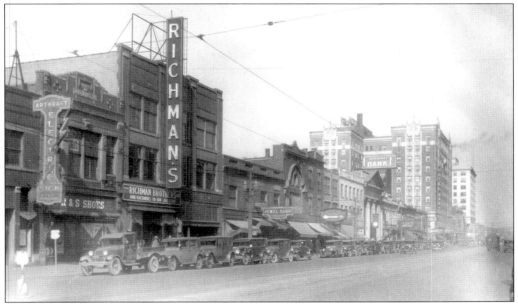

SEVENTH & BROADWAY, 1920S. Business was booming in the Steel City during the late 1920s. East Siders, like residents from other neighborhoods, had a host of stores, large and small, where they could spend their money. Parking was at a premium, but shoppers from the district could simply walk downtown or take the streetcar. This photo shows the west side of Broadway looking north from Seventh Avenue. (Courtesy of Calumet Regional Archives.)

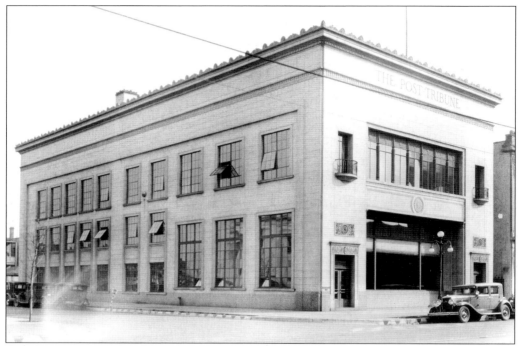

OLD POST-TRIBUNE. In the era before TV-news, the Steel City had daily morning and evening newspapers to keep its citizens informed. Of course, in those days, life moved at a much slower pace. Pictured is the main office of the *Post-Tribune* near Fourth Avenue and Broadway around 1930. The paper moved its operations to Eleventh and Broadway in the 1950s. (Courtesy of Calumet Regional Archives.)

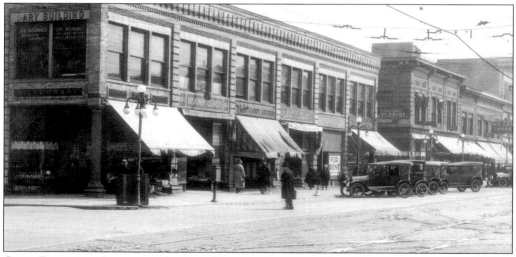

GARY BUILDING. It was not classic architecture, but many East Siders remember the old Gary Building that stood at the southeast corner of Fifth Avenue and Broadway. In its nearly 80 years of existence the structure housed a vast array of small businesses. This mid-1920s photograph shows angled parking and cobblestones running along the streetcar tracks. (Courtesy of Calumet Regional Archives.)

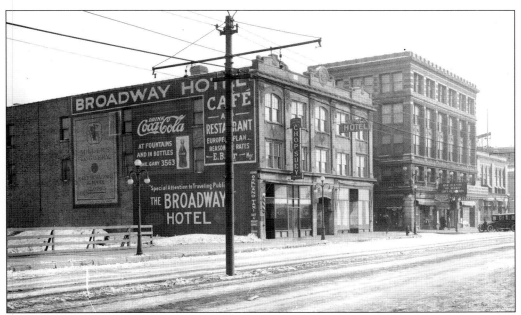

BROADWAY HOTEL. Small locally owned hotels were scattered throughout the East Side neighborhood. Pictured is the Broadway Hotel located in the 400 block of the Steel City's main business street. Just south is the Gary Theater. This picture was taken during the early 1920s. (Courtesy of Calumet Regional Archives.)

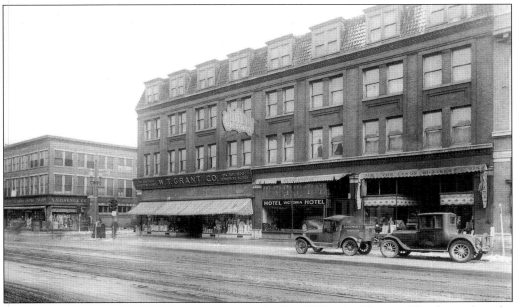

VICTORIA HOTEL AND W.T. GRANT 1920S. In the 1920s the Victoria Hotel stood at the southeast corner of Seventh Avenue and Broadway. W.T. Grant Company occupied a small area at the site with the Lennon Millinery. Thirty years later, the Grant Company tore down the structure and built a modern department store. Today, the area is a vacant lot. (Courtesy of Calumet Regional Archives.)

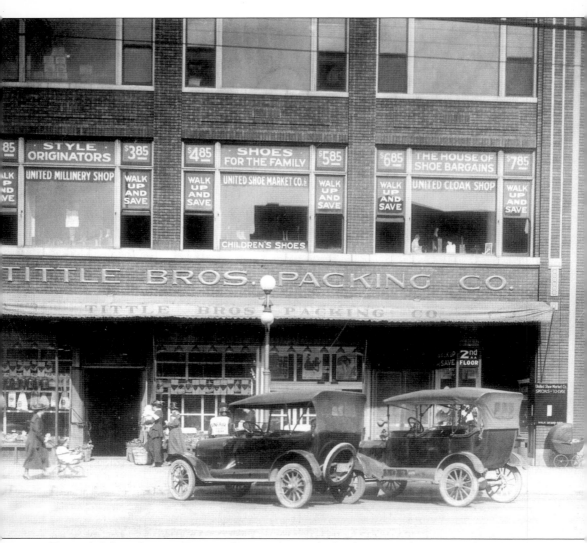

TITTLE'S MEAT STORE. For over 50 years the Tittle family operated a meat packing business in Gary. One of the early stores was on the 600 block of Broadway in the 1920s. The stores ceased business nearly a decade ago. (Courtesy of Calumet Regional Archives.)

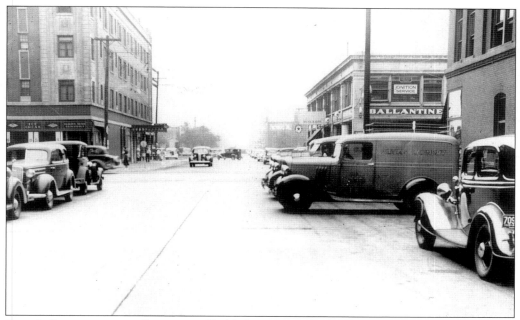

SLICK'S LAUNDRY AND CLEANERS. Slick's Laundry and Cleaners, a long time Gary business establishment, operated at Fifth Avenue and Massachusetts Street. A fleet of company trucks, at right, provided customers with pick up and delivery. Also pictured in this 1936 photo are the Dalton Apartments at right. (Courtesy of Calumet Regional Archives.)

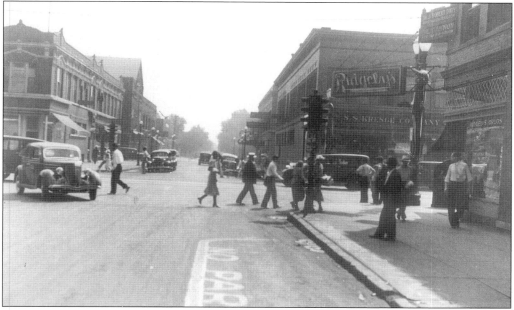

EAST SIXTH AVENUE, 1936. It was a typical Monday morning for Gary shoppers when this picture was taken on August 10, 1936. The view is of Sixth Avenue and Broadway looking east. The building at left was later Pearson's while the structure behind it was the old YWCA. (Courtesy of Calumet Regional Archives.)

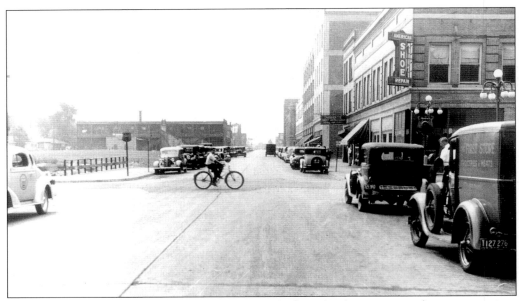

SIXTH AND MASSACHUSETTS, LOOKING SOUTH. Parking for shoppers was often at a premium along Broadway and motorists often did not fare any better on the side streets. Perhaps the individual riding the bicycle had the best idea. This view is of Massachusetts Street looking south from Sixth Avenue in 1936. The Radigan's and Goldblatts stores are visible to the south. (Courtesy of Calumet Regional Archives.)

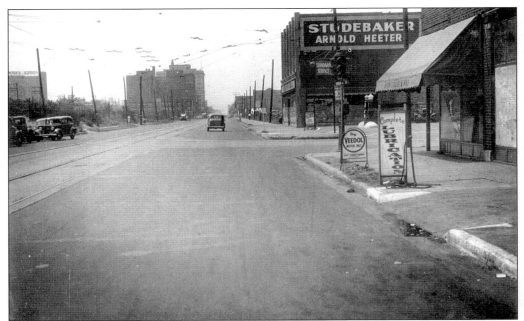

COZY CORNER. Afternoon traffic was much slower at Fifth Avenue and Virginia Street in the summer of 1936. Vacant lots were plentiful along the south side of the avenue (left). The building with the awning at right was later Cozy Corner Tavern. It was a popular watering hole with the mill workers on their way home. (Courtesy of Calumet Regional Archives.)

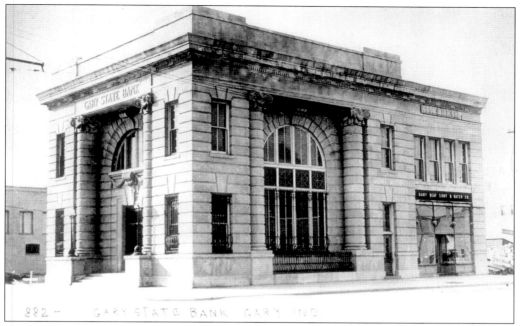

OLD GARY STATE BANK. Sound financial institutions were essential to a community's economic well-being. Located at Fifth Avenue and Broadway, the Gary State Bank was a well-managed establishment that provided security for the depositors from the East Side and the city of Gary. Pictured is the original bank around 1920. (Courtesy of Calumet Regional Archives.)

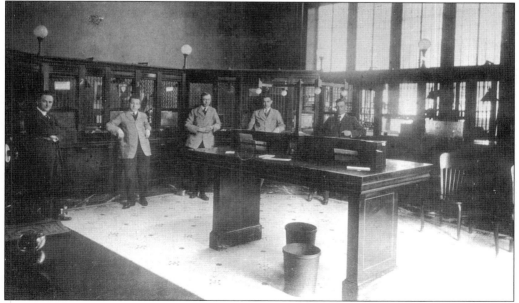

INTERIOR, GARY STATE BANK. Tellers stand before their business windows at the Gary State Bank at Fifth Avenue and Broadway around 1920. During the boom years of the late-1920s the financial institution constructed the 10-story structure that still occupies the southwest corner today. It is now Bank One. (Courtesy of Calumet Regional Archives.)

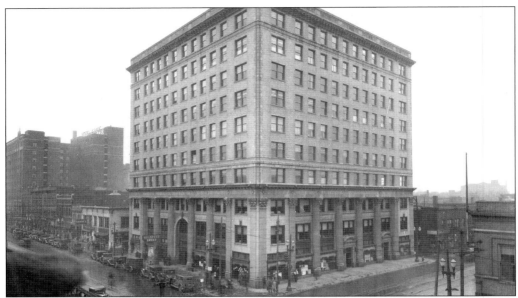

New Gary National Bank, 1920. During the 1920s, downtown Gary's skyline underwent dramatic changes. A new hotel, city hall, and county building were constructed. At the southwest corner of Fifth Avenue and Broadway the Gary State Bank erected a 10-story structure. The impressive building still stands out as part of the northern skyline. The building is pictured during the 1920s from across the street. To the left is the Gary Hotel. (Courtesy of Calumet Regional Archives.)

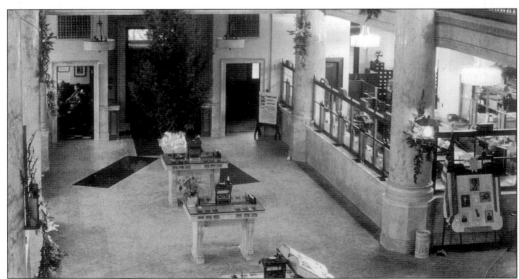

Gary National Bank Interior, 1942. Old East Siders and Steel City residents have vivid memories of the Gary National Bank (Bank One) that still operates at Fifth and Broadway. The ornate brass railings and window frames gave the main lobby class. Huge marble columns symbolized the stability of the institution. The picture was taken during the Christmas holidays of 1942. At the lower right are probably pictures of employees in the armed services. (Courtesy of Calumet Regional Archives.)

ARMOUR PACKING COMPANY. Armour and Company had a small packing plant just south of the Sears Roebuck Building on the east side of Broadway. The top picture was taken during a parade during the late 1950s or early 1960s. (Courtesy of Calumet Regional Archives.)

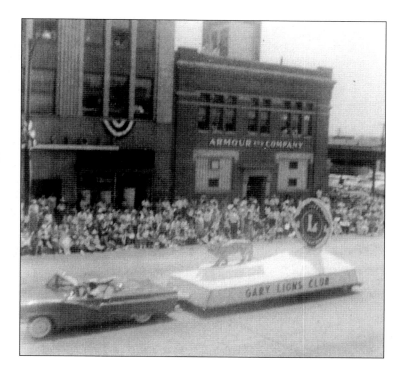

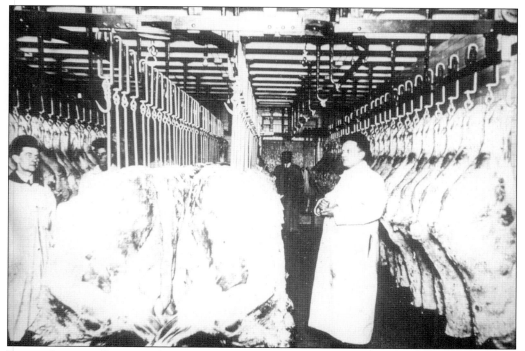

INSIDE ARMOUR PACKING COMPANY. Armour Packing workers check the slabs of meat before delivering them to local stores and butcher shops. This photograph was taken around 1930. (Courtesy of Calumet Regional Archives.)

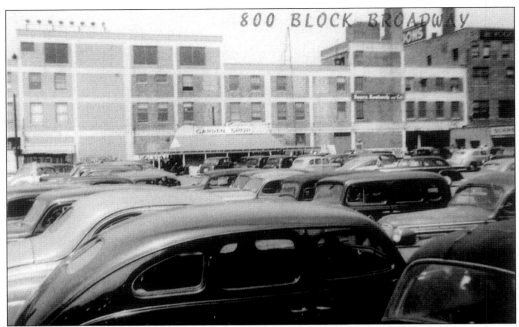

SEARS PARKING LOT. With the post-World War II economic boom, people had more money to spend on clothes, furniture, and appliances. Almost everything was American made. In this 1946 photo the Sears east parking lot is packed with shoppers' vehicles. At center is the store's garden shop. (Courtesy of Calumet Regional Archives.)

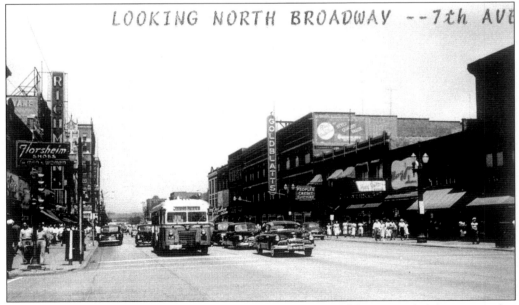

GOLDBLATTS. Before the days of the mega-discount stores Goldblatts provided shoppers with a variety of goods at low prices. East Siders fondly remember the delicatessen, which was packed every Saturday morning with buyers of meat, salads, and lunchmeats. This photograph of the 600 block was taken about 1950. (Courtesy of Calumet Regional Archives.)

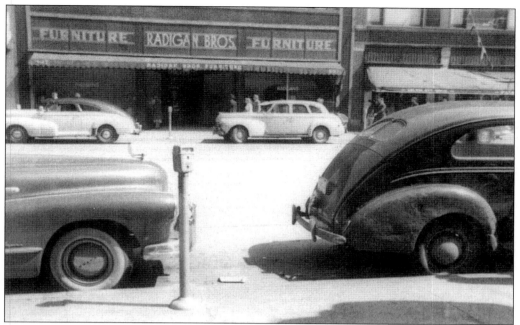

RADIGAN'S. Besides industry and national business chains, family-owned stores provided quality goods and jobs for East Siders. A long-time and respected establishment was Radigan Brothers Furniture located on the east side of the 600 Block of Broadway. Following the devastating fire that hit downtown in the late 1990s, the entire block was razed. (Courtesy of Calumet Regional Archives.)

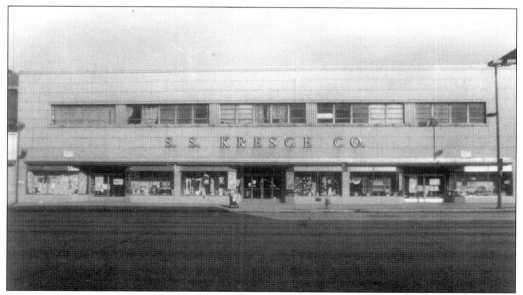

KRESGE STORE. Who can forget the Kresge Store located on the 700 block of Broadway? The discount store provided customers with a wide variety of inexpensive items. The store is shown here in the mid-1960s. It was built on the site of the burned-out Montgomery Ward's building. (Courtesy of Calumet Regional Archives.)

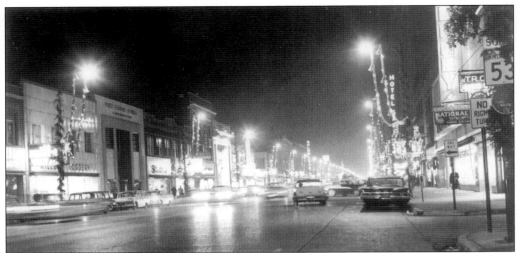

DOWNTOWN AT NIGHT. Suburban growth in the Region began after the Second World War but people still shopped in downtown Gary. The Steel City's main business district was still profitable in 1961 and able to lure evening Christmas shoppers. This view is of the east side of the 600 block of Broadway. (Courtesy of Calumet Regional Archives.)

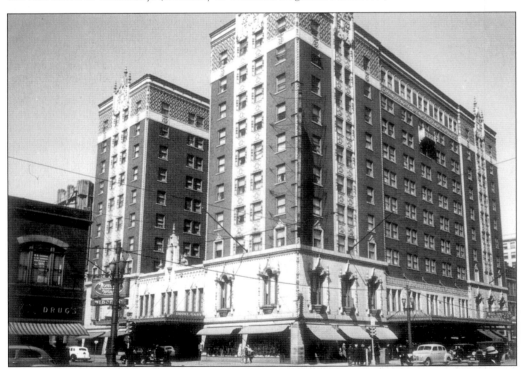

HOTEL GARY, 1950S. Hotel Gary was one of the finest lodging establishments in the Calumet Region. Its famous Crystal Ballroom played host to many wedding receptions and political dinners. Emerson High School held a number of proms and formal dances in that elegant hall. This picture shows the hotel in its hey-day during the early 1950s. Today the building at Sixth Avenue and Broadway is a Senior Citizen home. (Courtesy of Calumet Regional Archives.)

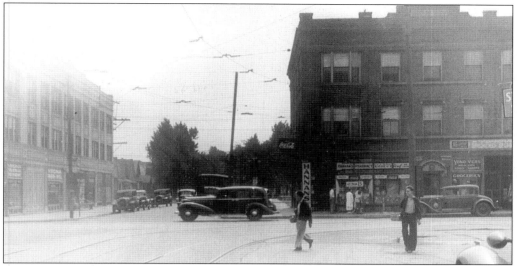

SNO-WHITE BAKERY. Fifth Avenue and Virginia was always a busy and popular intersection. It was a few blocks south of the Virginia Street gate to U.S. Steel. There were plenty of watering holes for the mill workers such as Cozy Corner, Virginia Tavern, and the Parkway. On the southwest corner was Hanan's Drug Store and later, the Sno-White Bakery. The area is pictured in 1936. (Courtesy of Calumet Regional Archives.)

EAST SEVENTH AVENUE. Two blocks south, other small businesses saw to the needs of East Siders. Along East Seventh Avenue there was Trainor's Tap. Across the street were Badanish Drugs, Jack's Barbershop, and Yamo's Food Market. Pictured are Robert Zalazar, Albert Alvarez, and Alez Sobh during the mid-1960s. (Courtesy of Calumet Regional Archives.)

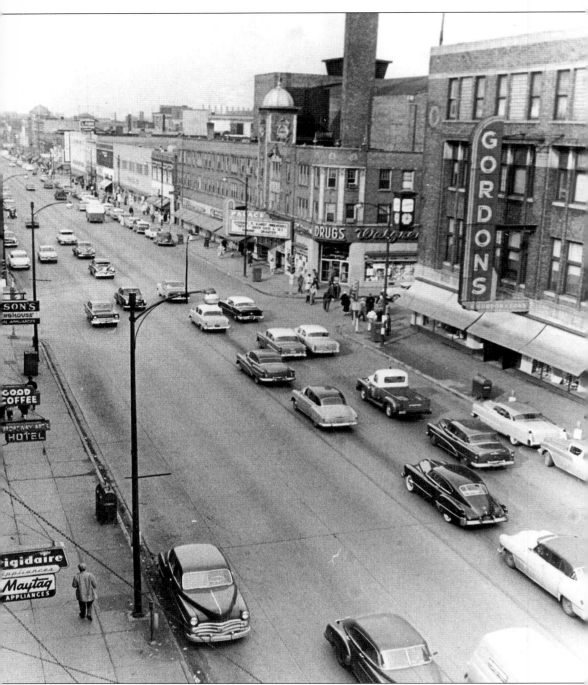

EIGHTH AND BROADWAY, 1956. In 1956 the area around Southlake Mall was just farmland. It was the downtown Gary commercial district that drew shoppers from throughout the Region. The steel mills were booming and people had money to spend. Gordon's Department Store and the elegant Palace Theater can be seen at the intersection of Eighth and Broadway. (Courtesy of Calumet Regional Archives.)

Four

POLITICS

Since the days of Thomas Knotts, Gary's first mayor, politics was a part of East Side life. The Steel City's first municipal building, which housed the mayor's office along with the police and fire station, was located at Seventh Avenue and Massachusetts Street. In the 1920s, a new city hall went up on the east side of Fourth Avenue and Broadway. Numerous presidential hopefuls, as far back as Woodrow Wilson in 1912, paid political visits to the city's chief executive.

Though Democrats controlled city hall since the New Deal of the 1930s, colorful mayors came from both parties. Popular Republican R.O. Johnson had to step down in the 1920s for violating the Volstead Act. After spending time in the Atlanta federal penitentiary, he ran again and won. In 1963, Democrat George Chacharis pleaded guilty to tax charges. It was said that had he run again following his release from prison, he would have easily won another term. That would have been interesting.

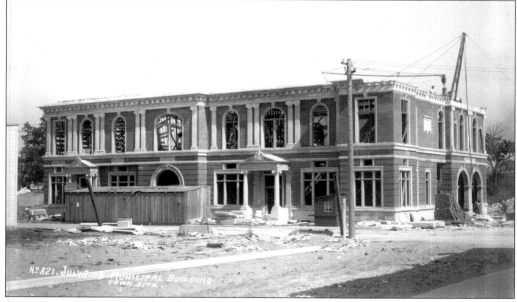

FIRST CITY HALL. Gary's first City Hall was constructed on the northwest corner of Seventh Avenue and Massachusetts Street in 1909. The Municipal Building housed the mayor's office, city court, and the police and fire stations. A long-time East Side fixture, it was torn down in the early 1950s. (Courtesy of Calumet Regional Archives.)

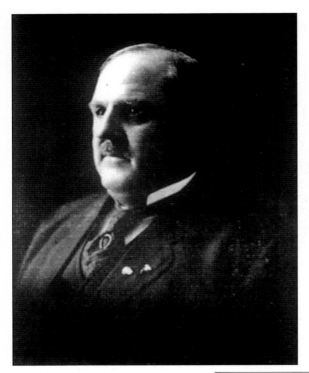

TOM KNOTTS. Thomas E. Knotts became the city's first mayor after winning a wild municipal election in 1909. During his term as the Steel City's chief executive, Gary's western borders were extended to Hammond and East Chicago. Miller and Glen Park were annexed. Knotts had his disputes with the steel company and the Republican-controlled Lake County Council. He lost the 1913 election and was Gary's only Democratic mayor until 1935. (Courtesy of Calumet Regional Archives.)

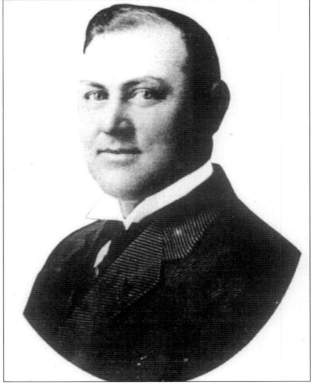

R.O. JOHNSON. Roswell O. Johnson, who defeated Thomas Knotts, would serve three terms as Gary's mayor. He was elected in 1913, then in 1921. In 1925 Johnson was sent to jail for violating prohibition laws. Pardoned by President Calvin Coolidge in March of 1929, he won the primaries and general election that year. However, the Great Depression provided his administration with a host of problems. (Courtesy of Calumet Regional Archives.)

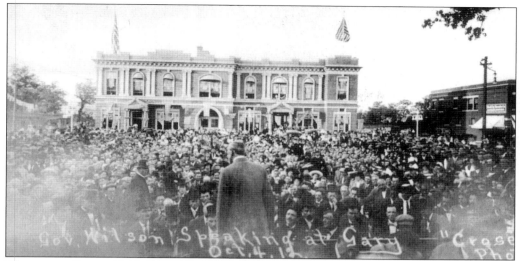

WILSON IN GARY, 1912. In 1912, Woodrow Wilson campaigned in Gary in his quest for the White House. The former president of Princeton University spoke to a crowd in front of Gary's old City Hall on Massachusetts Street. He would be one of many presidential hopefuls who would visit the Steel City and East Side. (Courtesy of Calumet Regional Archives.)

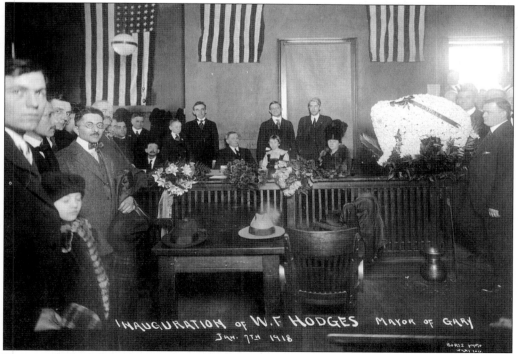

HODGES INAUGURATION, 1918. America was at war and many young men from throughout the city of Gary were in the service of their country. Still, the business of the city had to continue. On January 7, 1918, William F. Hodges was inaugurated as mayor of the Steel City. The ceremony took place in the municipal building on Seventh Avenue and Massachusetts Street. (Courtesy of Calumet Regional Archives.)

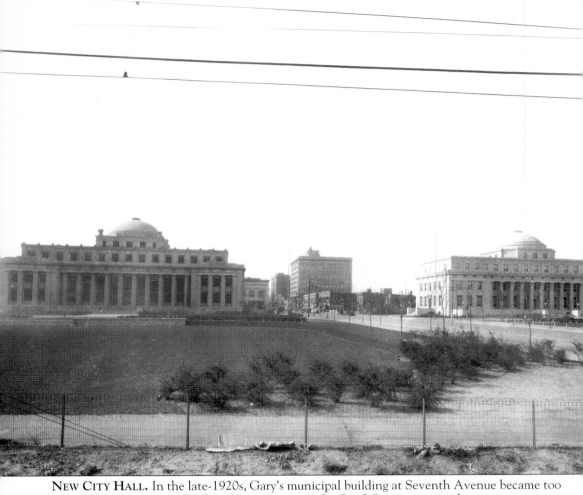

NEW CITY HALL. In the late-1920s, Gary's municipal building at Seventh Avenue became too cramped for operations. With a strong economy, the Steel City constructed a new structure at the southeast corner of Fourth Avenue and Broadway (left). At the same time a new County Courts Building (right) was put into operation across the street. The view is looking south from the South Shore Railroad tracks in 1931. (Courtesy of Calumet Regional Archives.)

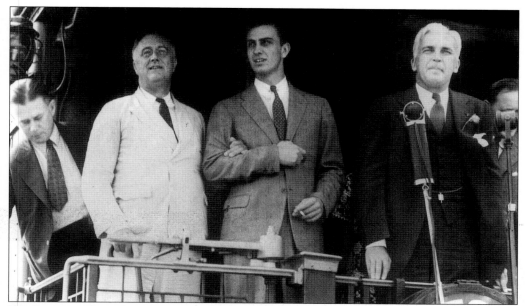

F.D.R., 1936 VISIT. In August of 1936, President Franklin D. Roosevelt's campaign train made a whistle stop in Gary. The place was the East Side's Baltimore and Ohio Railroad Station just south of the main gate of U.S. Steel's Gary Works. Pictured left to right: the President, his son Franklin Junior, and Indiana's governor, Paul V. McNutt. (Courtesy of Calumet Regional Archives.)

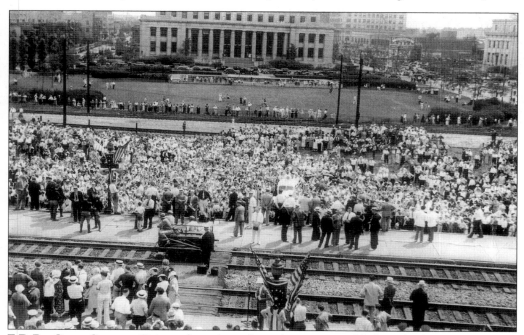

F.D.R., GARY CROWD. Citizens from throughout the area assembled north of Gateway Park to catch a glimpse of the popular president. F.D.R.'s programs brought hope to the people who lost so much because of the Great Depression. The 1930s saw the beginning of Democratic control of Lake County politics that continues today. (Courtesy of Calumet Regional Archives.)

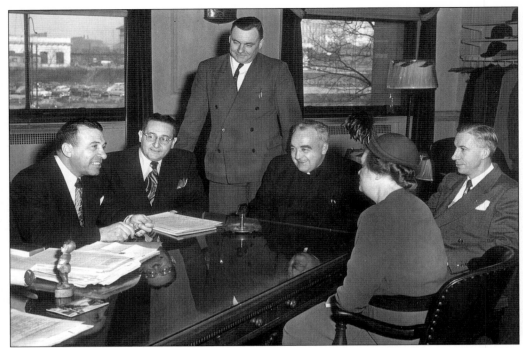

MAYOR SWARTZ AND CENSORS. Gary mayors had to meet with a variety of civic groups during their tenure as city chief executive. Here Mayor Eugene Swartz sits down with the Gary Board of Censors in the east side city hall in 1950. (Courtesy of Gary CYO.)

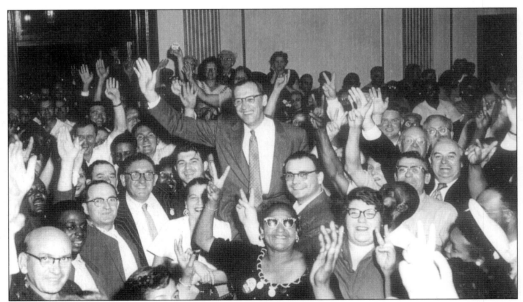

PETE MANDICH VICTORY 1955. It was a big victory as Mayor Peter Mandich won the Democratic primary election in May of 1955. Later, in the general election Mandich defeated Emery A. Badanish to become the first Steel City mayor to win two successive terms. To his right is City Controller, George Chacharis. (Courtesy of Calumet Regional Archives.)

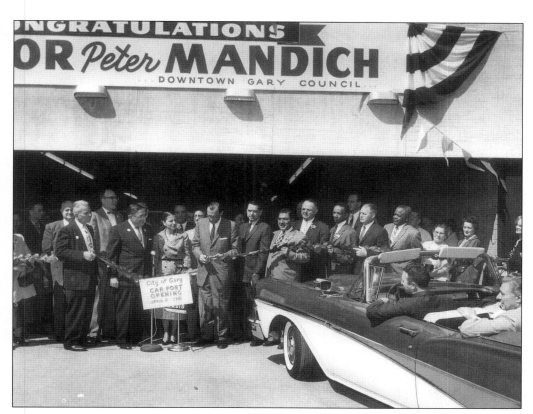

MANDICH RIBBON CUTTING. When not campaigning for votes, political figures love the limelight, even at groundbreaking or ribbon cutting ceremonies. Here Mayor Peter Mandich and members of his administration gather for the opening ceremonies of the municipal carport at Seventh Avenue and Massachusetts Street in 1958. The site was once the home of the original city hall. (Courtesy of Calumet Regional Archives.)

JOHN PECK APPOINTMENT. In December of 1957, John Peck was appointed the city's first zoning administrator by Mayor Peter Mandich. John was a 1943 Graduate of Emerson High School and is a member of St. Hedwig Parish. (Courtesy of John Peck.)

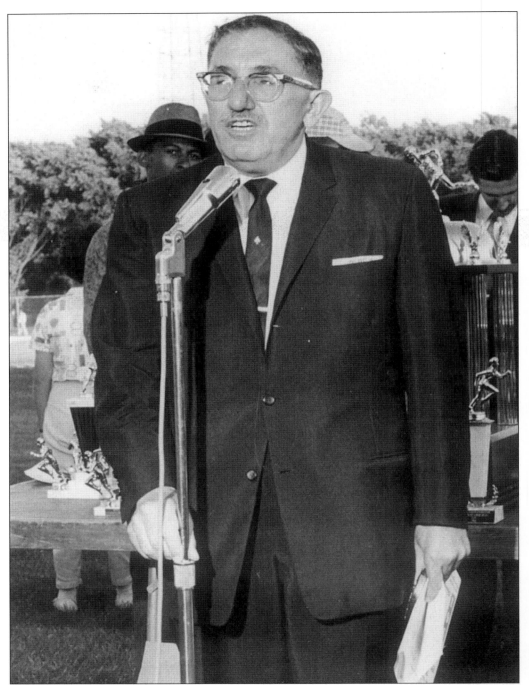

MAYOR CHACHARIS, 1960. George Chacharis served as the Steel City's chief executive from 1958 until his resignation in 1962. He stepped aside after pleading guilty of conspiring to avoid tax payments in Hammond Federal Court. Though he served a two-year sentence, many believed that if "Cha-Cha" ran again, he would win. He is pictured here in better times taking part in an award ceremony around 1960. (Courtesy of Calumet Regional Archives.)

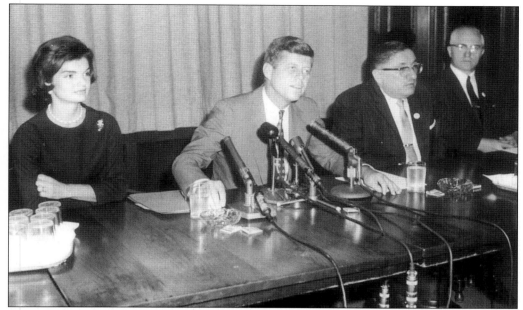

KENNEDY VISIT, 1960. Old-fashioned Gary politics made way for John F. Kennedy and Camelot during the 1960 presidential election. Kennedy paid the Steel City a visit during his campaign to secure votes from the predominately Democratic stronghold. Pictured from left to right at city hall are Jackie Kennedy, candidate John, and Mayor George Chacharis. (Courtesy of Calumet Regional Archives.)

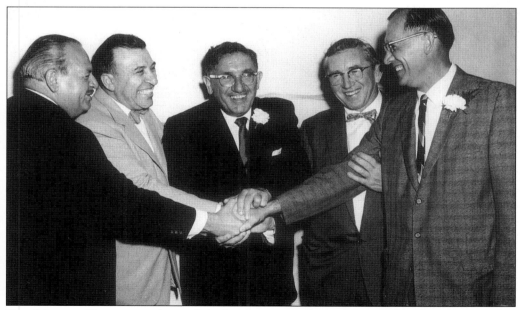

FIVE MAYORS TOGETHER. At a political gathering, the Mayor George Chacharis got together with former city chief executives. Pictured left to right: Wally Jeorse of East Chicago, Eugene Swartz, Chacharis, Joseph Finerty, and Peter Mandich, all of Gary. The picture was taken around 1960. (Courtesy of Calumet Regional Archives.)

JOHN VISCLOSKY, MAYOR. With the resignation of Mayor George Chacharis, John Visclosky became the city's chief executive in 1963. He served until January of 1964 following the election of Judge A. Martin Katz as mayor. Today his son Peter is Indiana's representative to the U.S. House. (Courtesy of Calumet Regional Archives.)

A. MARTIN KATZ. A. Martin Katz served as Gary's chief executive from 1964 to 1968. In 1963 he defeated his main challenger, businessman Emery Konrady, in a crowded Democratic primary. Prior to his term as mayor he served as city judge. In May of 1967, Mayor Katz was defeated by then Councilman Richard Gordon Hatcher. (Courtesy of Calumet Regional Archives.)

RICHARD G. HATCHER. For the first time in years a Republican had a chance to occupy city hall as Gary Democrats were divided following the 1967 mayoral primary. Though Judge A. Martin Katz had the blessings of the machine, councilman Richard Gordon Hatcher won the party nomination. Many long-time party faithfuls would not support an African-American for mayor. Hatcher won the November general election defeating businessman Joseph Radigan. He is pictured with Vice-President Hubert Humphrey in 1967. (Courtesy of Calumet Regional Archives.)

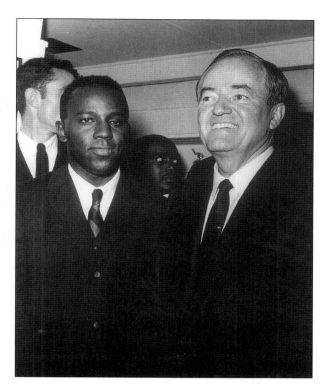

THOMAS BARNES. Thomas Barnes served two terms as Gary's mayor. His first victory in the city's Democratic primary signaled the end of the 20-year political control of city hall by the administration of Mayor Richard Gordon Hatcher. Former Mayor Barnes was a member of the U.S. Army Reserve and served in the Judge Advocate General's office. (Courtesy of Calumet Regional Archives.)

SCOTT KING. Today Scott King serves as the Steel City's chief executive. He took office in January of 1996 and his first term was a constant battle with the city council. He won reelection by a wide margin and many of his council adversaries were replaced with a more cooperative legislative group. (Courtesy of Calumet Regional Archives.)

Five

St. Luke

Two institutions that preserved neighborhood strength and stability were the churches and schools. In 1917, Bishop Herman J. Alerding of the Diocese of Fort Wayne assigned Rev. Frank J. Gnibba to serve as pastor for the Catholic population on the Steel City's East Side. Work began immediately on a combination church and school as well as a rectory around Seventh Avenue and Rhode Island Street. In keeping with a plan to name the early churches in Gary for the gospel writers, the parish was named for St. Luke.

Many referred to the surrounding neighborhood as "Little Ireland" since a great number of residents were of Irish decent. There were 125 original members and the young parish saw to the spiritual and educational needs of all East Side Catholics. In time adult religious and social organizations were founded and athletic programs were set up for the school's students.

In the summer of 1954, the cornerstone was laid for the present church and the structure was dedicated the following year. Though the school closed in the late 1960s, the East Side parish, now St. Monica-St. Luke, continues its spiritual mission to the community.

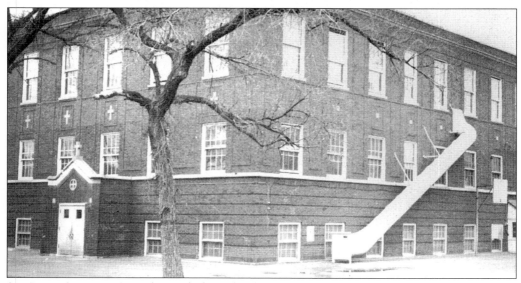

St. Luke School. St. Luke Catholic School, located at Seventh Avenue and Rhode Island Street, was actually built in three phases. The basement served as the original church. A few years later, classroom space was added with the second floor. Finally, more classes were provided with the addition of the third floor. The fire escape chutes were added in the 1950s. (Courtesy of Diane Trafny-Greenwood.)

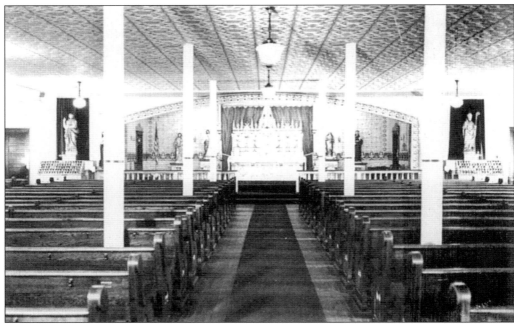

Inside Old St. Luke Church. St. Luke's Parish Church was dedicated by Bishop Herman J. Alerding in 1917. Located on the lower level of the church-school building on East Seventh Avenue, it served the needs of East Side Roman Catholics. Originally, the Diocese of Fort Wayne planned to name the first four parishes after the gospel writers, Matthew, Mark, Luke, and John. Only St. Mark Parish in the Glen Park section was constructed. Other parishes took different names. (Courtesy of Diane Trafny-Greenwood.)

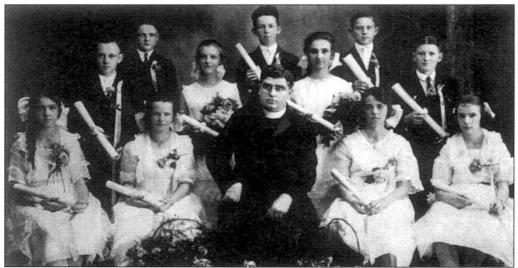

St. Luke Graduation, 1921. There was great joy in the spring of 1921 as 11 eighth graders received their diplomas. Though the Class of 1921 was small, enrollment continued to rise at the East Side Catholic school. Pictured with the graduates was the Rev. Frank J. Gnibba, the first pastor of St. Luke Parish. (Courtesy of Diane Trafny-Greenwood.)

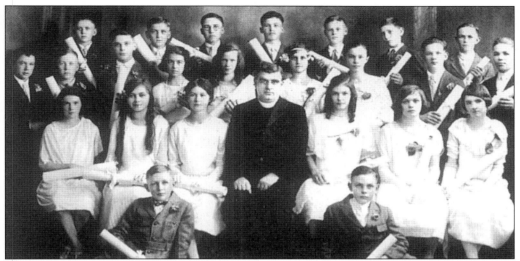

ST. LUKE GRADUATION, 1922. With the Steel City's economy on the upturn in the early 1920s, more East Side families were able to provide a Catholic grammar school for their children. The number of graduates more than doubled for the St. Luke Class of 1922. (Courtesy of Diane Trafny-Greenwood.)

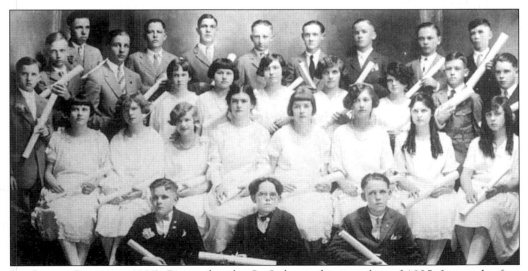

ST. LUKE, CLASS OF 1925. Pictured is the St. Luke graduation class of 1925. It was the first group of graduates to attend all eight years at the East Side Catholic school. (Courtesy of Diane Trafny-Greenwood.)

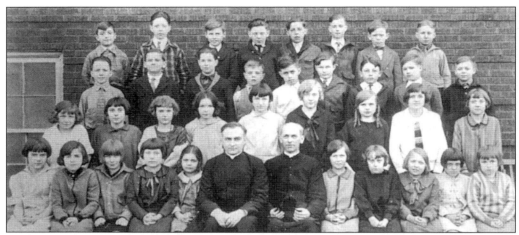

SIXTH GRADE, ST. LUKE 1927. Class picture day became traditional at schools throughout the Calumet Region. Parents made sure their children would be properly dressed and groomed, whether they liked it or not. Pictured is the sixth grade class of St. Luke School, 1926-27. At center is the assistant pastor, Rev. Theodore Fetting and the Rev. Ralph Donnelly, pastor. (Courtesy of Diane Trafny-Greenwood.)

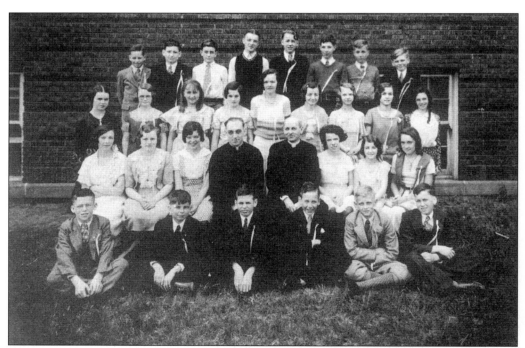

ST. LUKE, CLASS OF 1932. Depression and hard times devastated the region's economy, but on this day St. Luke Parish had reason to celebrate. The graduates of the Class of 1932 received their diplomas and were ready for new challenges. Those more fortunate would go on to high school while others, because of financial need, would seek employment to help their families. (Courtesy of Diane Trafny-Greenwood.)

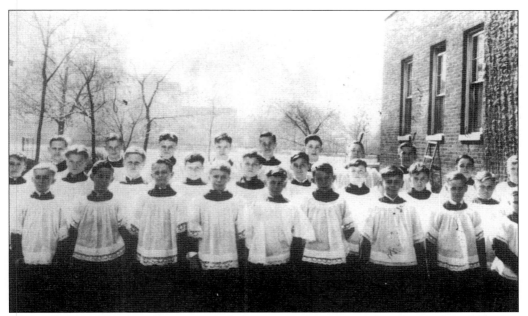

ALTAR BOYS, 1938. Altar boys were a select group chosen to assist the priest in the celebration of mass. They were fourth graders and older, and before the Second Vatican Council in the early 1960s, were required to learn their prayers in Latin. Besides daily and Sunday masses, the lads assisted at weddings, funerals, and holy days of obligation. Pictured are the St. Luke altar boys of 1938. (Courtesy of Diane Trafny-Greenwood.)

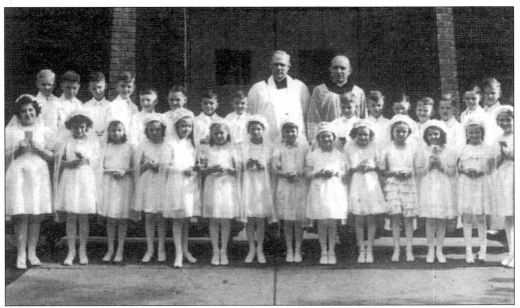

FIRST COMMUNION, 1944. First Communion was a special day to youngsters and their families. In 1944, it was also a special day of prayer. The third graders offered thanks and special prayers for family members and neighbors who were serving their nation in distant lands for the cause of freedom. (Courtesy of Calumet Regional Archives.)

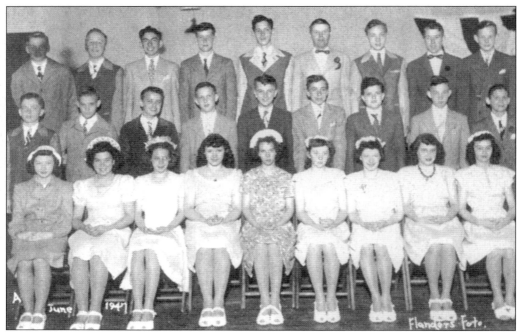

ST. LUKE GRADUATION, 1947. With the Second World War over, East Side families wanted to return to the stability they remembered prior to 1941. Like their own parents, young Catholic families in the neighborhood did their best to provide a faith-based education for their children. Pictured is the St. Luke Graduation Class of 1947. (Courtesy of Diane Trafny-Greenwood.)

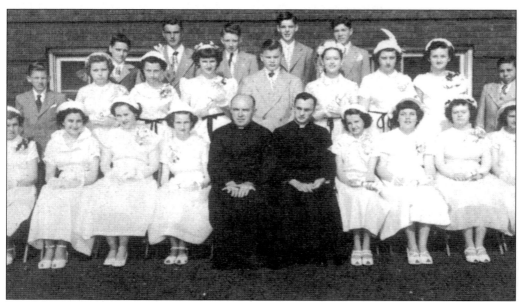

ST. LUKE, CLASS OF 1950. The decade of the 1950s was often considered conservative. Still, graduation day was a time for enjoyment and anticipation of the future. Pictured is the St. Luke Class of 1950 with Father Carl J. Schnitz and Father Matthew Spebar. (Courtesy of Diane Trafny-Greenwood.)

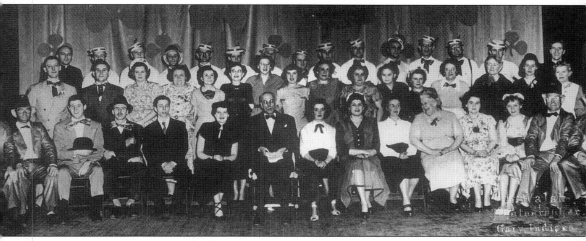

St. Luke Play, 1951. From the late 1920s until the 1950s, Irish plays were presented by St. Luke's Parish. Parishioners were invited to try out for roles in the annual productions. Such events served to strengthen community involvement on the East Side. Pictured are members of the cast of *The Irish Minstrels* in 1951. (Courtesy of Diane Trafny-Greenwood.)

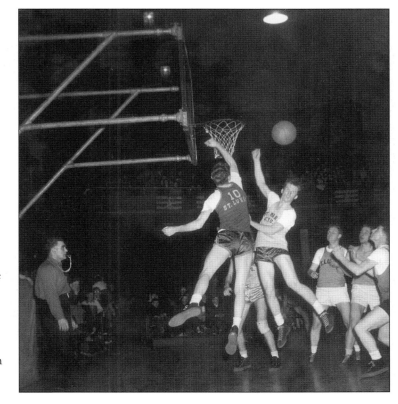

St. Luke Basketball, 1950. As the shot bounces off the rim players from St. Luke and their opponents from St. Mary's wait for the rebound. This 1950s Catholic Youth Organization (CYO) contest was played at the Knights of Columbus Building on West Fifth Avenue. (Courtesy of CYO.)

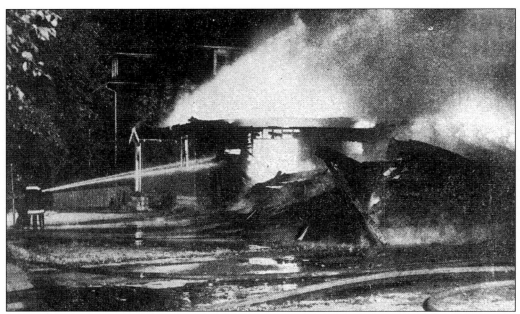

St. Luke Fire, 1954. In September of 1954, St. Luke Parish fell victim to a fire. The combination school hall and former convent were destroyed. Only burned rubble remained. (Courtesy of Diane Trafny-Greenwood.)

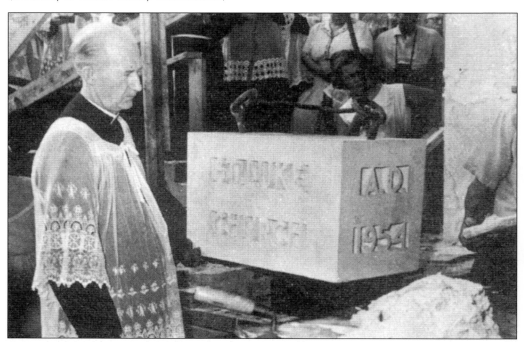

Church Cornerstone Laid. On August 22, 1954, the parishioners of St. Luke joined their pastor, the Rev. Wilfred Mannion, in thanks and prayer as the cornerstone for the new church was laid. A huge outpouring of parish donations helped finance the project. (Courtesy of Diane Trafny-Greenwood.)

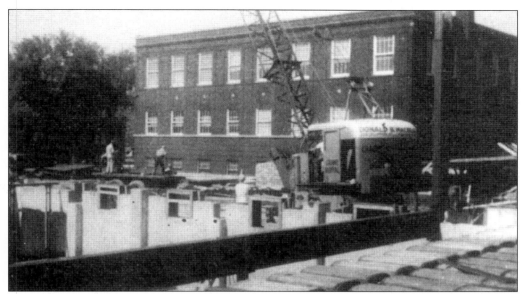

ST. LUKE CONSTRUCTION. Ground was broken for the new St. Luke Church in February of 1954. Almost immediately construction crews went to work. One of the first jobs was building a parish hall beneath the new structure. The school sits in the background. (Courtesy of Diane Trafny-Greenwood.)

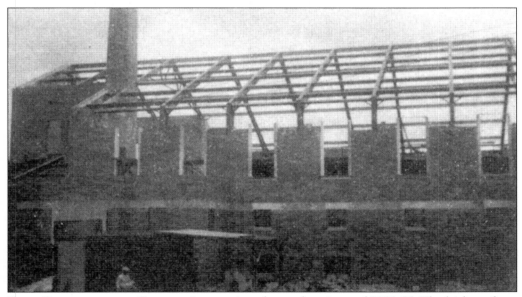

ROOF CONSTRUCTION. Construction continued over the winter of 1954-55. The high roof was supported by a maze of steel beams and rods. Once complete, the church would be one of the largest in the diocese. (Courtesy of Diane Trafny-Greenwood.)

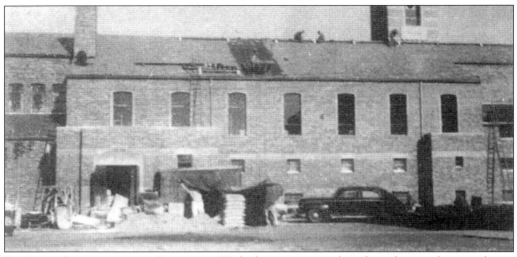

ST. LUKE CONSTRUCTION, INTERIOR. With the masonry and roof nearly complete, work was accelerated on the interior of the church structure. Construction crews focused on electrical work, plumbing, stained-glass windows, and painting. (Courtesy of Diane Trafny-Greenwood.)

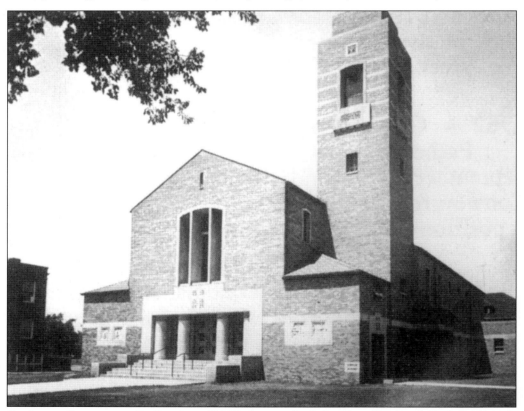

ST. LUKE, COMPLETED. In October of 1955, the new St. Luke Church opened. Dedication took place a few weeks later on November 6th. A dream was finally achieved. (Courtesy of Diane Trafny-Greenwood.)

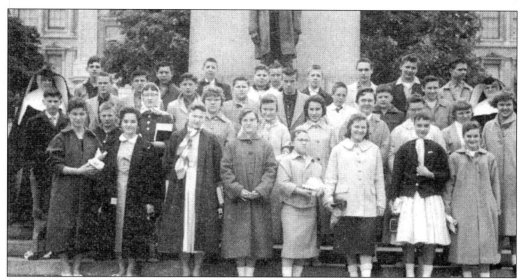

ST. LUKE FIELD TRIP, 1957. School field trips provided students with a chance to travel with friends and learn about the history of different communities. For chaperones, getting everyone home safely was a challenge in itself. In 1957, the eighth graders of St. Luke School visited Springfield and the Land of Lincoln. (Courtesy of Diane Trafny-Greenwood.)

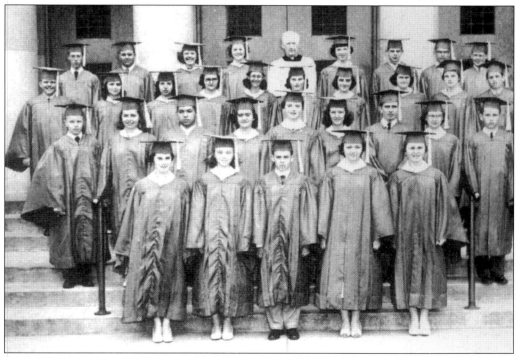

ST. LUKE, CLASS OF 1958. Pictured is the 1958 Graduation Class of St. Luke with the Rev. Wilfred P. Mannion, pastor. With Andrean High School still under construction, graduates went on to Emerson or Bishop Noll Institute in Hammond, Indiana. (Courtesy of Diane Trafny-Greenwood.)

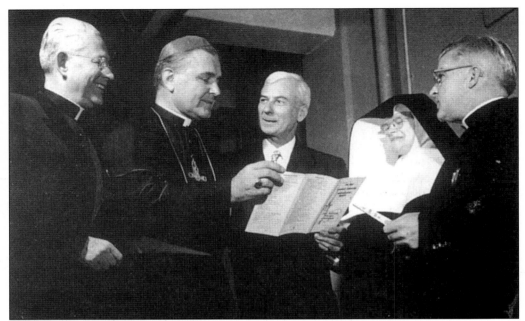

ST. LUKE TEACHERS GROUP. In 1958, the first Gary Diocese Teachers' Convention was held at St. Luke Parish. Pictured from left to right are: Monsignor H. James Conway, Bishop Andrew Grutka, Mr. John Trainor, Sister Liboria, and the Rev. Gilbert Wirtz. (Courtesy of Diane Trafny-Greenwood.)

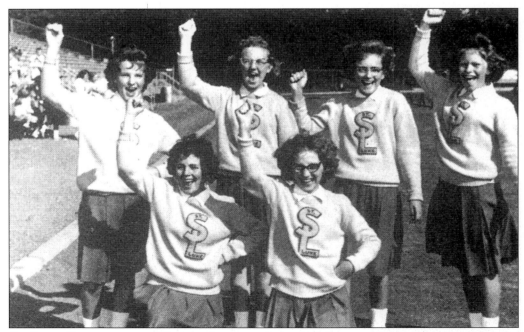

ST. LUKE CHEERLEADERS. Cheerleaders have always led the crowd to provide support for the home team. Here the St. Luke squad poses for a photo at Gilroy Stadium in 1961. (Courtesy of Diane Trafny-Greenwood.)

KITCHEN STAFF. The members of the kitchen staff were an essential group at St. Luke. They had to make sure a nutritious meal was ready every school day for the students—whether they liked it or not. Pictured is Mrs. Albert Hennessy, who supervised kitchen operations at St. Luke's Hall Kitchen. (Courtesy of Diane Trafny-Greenwood.)

HAL HIPPIE. Teachers, administrators, and the secretarial staff were there to see to the everyday operation of the school. However, the custodians made sure that the school building and grounds were maintained throughout the year. They had no summer vacation. Pictured is Hal Hippie who gave 12 years of faithful service to St. Luke Parish. (Courtesy of Diane Trafny-Greenwood.)

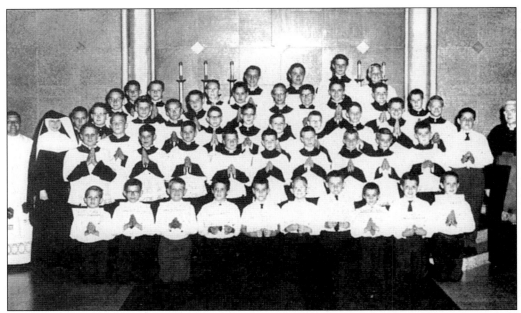

ALTAR BOYS, 1962. At one time, St. Luke Parish celebrated at least four Sunday and two daily masses. The need for altar boys to assist at mass was great. Pictured are the student servers in 1962. (Courtesy of Diane Trafny-Greenwood.)

SISTER'S CHAPEL. A place most parishioners of St. Luke never had the opportunity to see was the chapel in the Sister's Convent. Each morning the sisters took part in the celebration of mass, and then went about their daily duties. (Courtesy of Diane Trafny-Greenwood.)

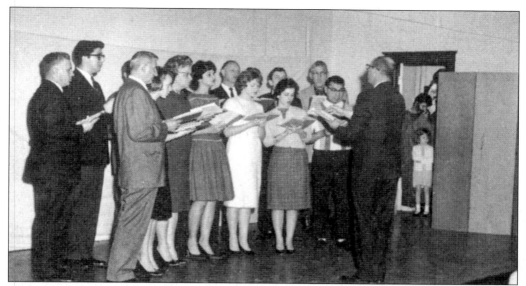

CHURCH CHOIR, 1964. To have a successful church choir, a parish needs a dedicated group and director that are willing to work together. Hours of practice have to be put in. Pictured is the St. Luke Church Adult Choir at rehearsal in 1964. Myron Rupp served as director and Mrs. Paul Calloway was the organist. (Courtesy of Diane Trafny-Greenwood.)

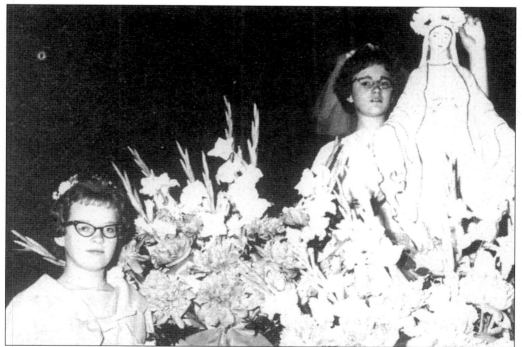

MAY CROWNING. During the month of May, Roman Catholics have honored Mary, the mother of Jesus. Many parishes in the Calumet Region held special religious ceremonies to pay homage. At each parish schoolgirls were chosen to take part in the liturgy. Pictured is the May Crowning at St. Luke in 1962. (Courtesy of Diane Trafny-Greenwood.)

ST. LUKE RECTORY. In 1917, the rectory of St. Luke Parish was constructed along with the church. Over the years, the building gradually sank into the soft sand and became known as the "Leaning Tower of Vermont Street." The structure, pictured in the 1960s, was demolished in the 1980s. The parish offices and the pastor's residence were moved to the convent. (Courtesy of Diane Trafny-Greenwood.)

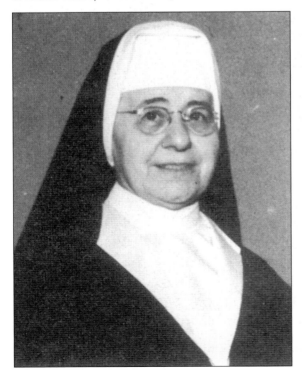

SISTER MAXIMILLA. Sister Maximilla, SSND, served as principal of St. Luke School from 1958 to 1963. Besides her administrative responsibilities, she taught and carried out numerous duties at the parish church. She is pictured here during the 1960s. (Courtesy of Diane Trafny-Greenwood.)

CHARLEBOIS FAMILY. A number of sons and daughters of the St. Luke Parish family were called to serve the Lord. One mother, Mrs. Mary Charlebois, was especially proud. Two of her sons were ordained into the priesthood. Pictured are Father Robert Charlebois, Mrs. Charlebois, and Monsignor John Charlebois. (Courtesy of Diane Trafny-Greenwood.)

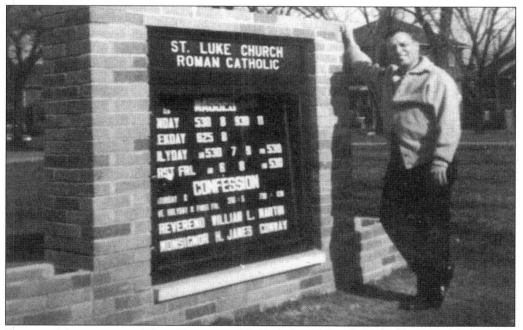

FATHER MARTIN AND NEW BULLETIN BOARD. In 1962, the parish men's organization constructed an outdoor bulletin board on the lawn in front of the church. Here, the popular assistant pastor, the Rev. William Martin, poses before the completed project. (Courtesy of Diane Trafny-Greenwood.)

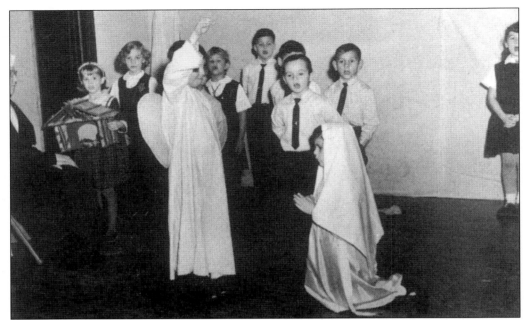

FIRST GRADE PLAY. As the Christmas holidays drew closer, everyone from the parish and school prepared for the celebration of Christ's birth. School children learned the true meaning of Christmas by taking part in class plays. The most enjoyable—mistakes and all—were performed by the youngest school children. Here the first graders of St. Luke School reenact their version of the Nativity in 1964. (Courtesy of Calumet Regional Archives.)

SETTLE BROTHERS. It was an East Side family affair for the Settle brothers. All were altar boys at St. Luke Parish in the 1960s. Pictured left to right were: George Jr., Leo, Ralph, and Joseph. (Courtesy of Diane Trafny-Greenwood.)

1965 Catholic Youth Organization (CYO) Champions. During the 1965-1966 school year, St. Luke's CYO football and basketball teams were crowned champions. Pictured, at Gilroy Stadium, is the City Football Championship team. (Courtesy of Gary CYO Archives.)

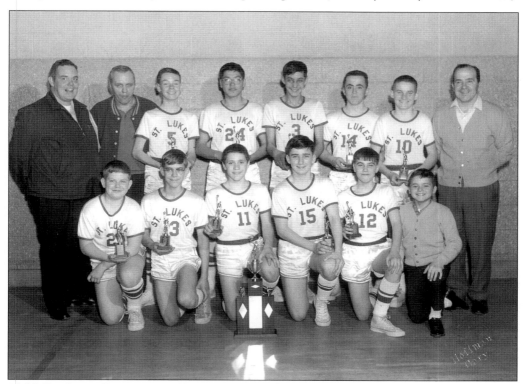

1966 St. Luke Basketball Team. In 1966, the St. Luke boy's basketball squad won the division competition. Here, players, coaches, and manager pose for the traditional team photo. (Courtesy of CYO.)

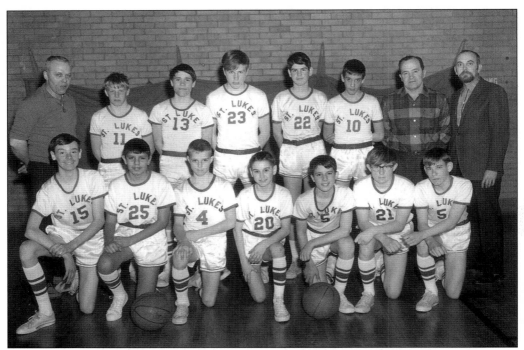

BASKETBALL, 1967. The 1967 St. Luke Boy's Catholic Youth Organization (CYO) Basketball team. (Courtesy of Gary CYO.)

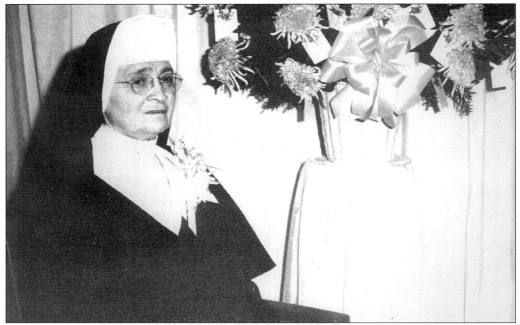

SISTER FINCELLA. In 1966, Sister Mary Fincella, SSND, celebrated 60 years of service to the Lord and the community. The good sister dedicated 35 years to St. Luke Parish. (Courtesy of Diane Trafny-Greenwood.)

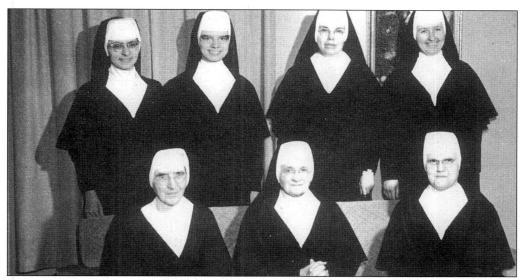

SISTERS, 1967. During the Golden Jubilee year, seven Sisters of Notre Dame served St. Luke Parish. Seated from left to right are Sister Isabel, Sister Fincella, and Sister Leonard. Standing from left to right are Sister John Miriam, Sister Cynthia Ann, Sister Bellamine, and Sister Lenise (Principal). (Courtesy of Diane Trafny-Greenwood.)

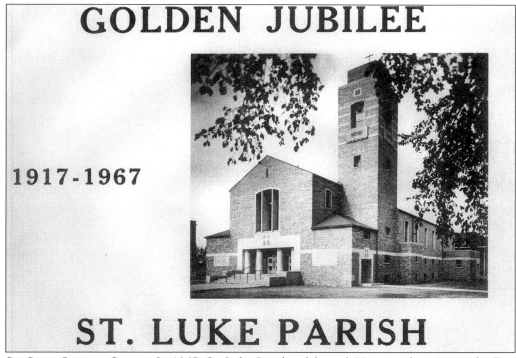

ST. LUKE JUBILEE COVER. In 1967, St. Luke Parish celebrated 50 years of service to the East Side and the city of Gary. While restricted to the parish rectory because of the January 1967 blizzard, the Rev. William Martin began work on a commemorative history of the parish. The front cover of the anniversary booklet is pictured. (Courtesy of Diane Trafny-Greenwood.)

JUBILEE CLASSES

When St. Luke Parish celebrated its 50th anniversary in 1967, the Jubilee Committee and Father William Martin put together a pictorial history of the East Side Church. Included were class photos of all eight grades and their teachers.

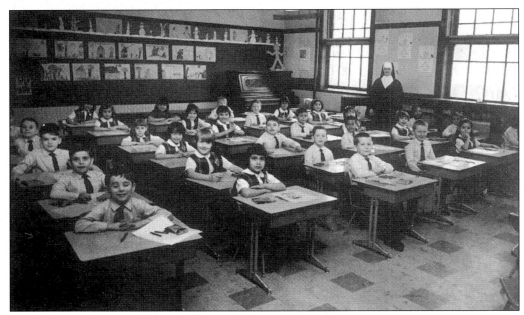

GRADE 1 SISTER LEONARD

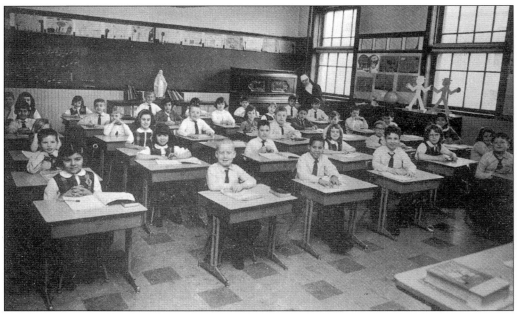

GRADE 2 SISTER JOHN MIRIAM

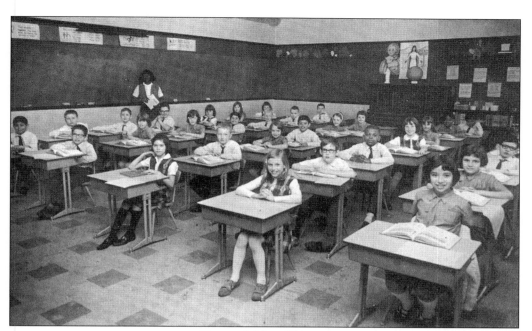

GRADE 3 MRS. HARRIS

GRADE 4 SISTER BELLARMINE

GRADE 5 MRS. SICULA

GRADE 6 MR. SMENYAK

GRADE 7 SISTER CYNTHIA ANN

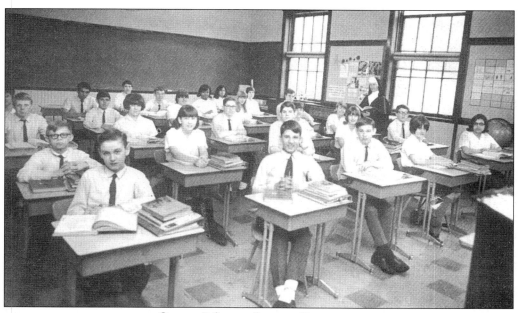

GRADE 8 SISTER LENISE, PRINCIPAL
(Courtesy of Diane Trafny-Greenwood.)

REV. FRANK GNIBBA. In 1917, Rev. Frank J. Gnibba, assistant pastor at Holy Angels Church, was assigned the task of organizing a new parish on the east side. By the fall of that year, 146 families were part of the new congregation and 90 students were enrolled in the parish school. During Father Gnibba's stewardship, a church, school, rectory, and convent were constructed. Parish social groups were organized, and numerous fund raising activities began to reduce the young parish's debt. (Courtesy of Diane Trafny-Greenwood.)

FATHER MANNION. Under the Rev. Wilfred P. Mannion, the construction of the present church was completed. In a little over a year the structure was dedicated and put to use for the spiritual needs of East Side parishioners. Father Mannion celebrated his Silver Jubilee of priesthood while serving the parishioners of St. Luke. (Courtesy of Diane Trafny-Greenwood.)

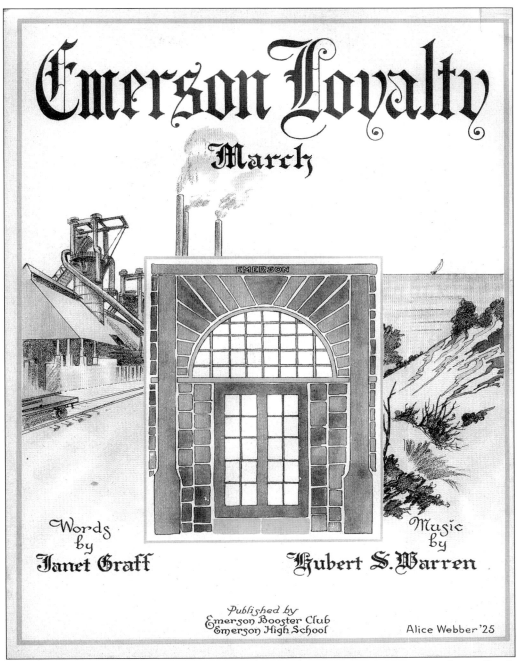

EMERSON FIGHT SONG, COVER. Emerson High School was unique in many ways. It was Gary's first high school and served as the educational lab for Dr. William Wirt's program. The school also had its own school song, unlike so many others that were replays of "On Wisconsin," but with different words. Janet Graff wrote the words to "Emerson Loyalty" while Hubert S. Warren did the music. Pictured is the cover to the sheet music. It was designed by Alice Webber for the Emerson Booster Club. (Courtesy of Betty Barrett Ripley.)

EMERSON BOULDER. Located at the southwest corner of the Emerson campus sits a community landmark—the boulder. It was a gift to the school by the Class of 1943. (Courtesy of John Peck.)

CLASS OF 1943, 50TH REUNION. In 1993, the Emerson Class of 1943 met once again for their 50th Reunion. As youngsters, they and their families faced the hardships of the Great Depression. When they graduated from high school, each in his or her own way helped America defeat the German war machine and the Empire of Japan. When each returned, they were part of the great post-war economic boom. They were part of America's Greatest Generation. (Courtesy of Bernice Balicki.)

GOLD TO GRAY

Betty Barrett Ripley, Editor

Newbury Park, CA 91320
Note: New address and phone number.

Emerson High Graduates
And Eastsiders

JAMES MC GREGOR - Graduated from Emerson, Class of 1936
 When Jim died in 1995, his wife, Charlotte found among his things a poem he'd written.
 The poem, "Elegy," deals with a World War II soldier's thoughts of Indiana while stationed in the South Pacific.

ELEGY

There's a bit of Indiana in the sighing of the breeze.
There's a hint of Indiana in the rustling on the trees.
And the jungle's myriad whisperings are sibilantly clear;
(They are having Injun Summer, just ten thousand miles from here.)

There's a part of Indiana in the blazing tropic moon.
There's a trace of Indiana in the shimmering lagoon.
And a message in the tramping of a sentry very near:
("Oh the frost is on the punkin," just ten thousand miles from here.)

There's a share of Indiana in the crosses by the palms.
There's a trace of Indiana in the South Pacific calms,
And the murmur of the breakers brings me desolating cheer:
(Oh, the corn is heavy on the stalk, ten thousand miles from here.)

There's a piece of Indiana where the sand is stained with red.
There's a lot of Indiana where this Hoosier lays his head.
And I seem to hear him saying as I stand beside his bier,
(Let me sleep once more beneath the sky, ten thousand miles from here.)

James McGregor
Biak Island
February, 1944

JAMES MCGREGOR POEM. Over the years, Mrs. Betty Barrett Ripley has published the newsletter, *Gold to Gray* that provided Emerson graduates with information on their classmates, reunions, and social gatherings. In 1999, she printed a poem by James McGregor, a 1936 graduate of Emerson High School and veteran of the South Pacific. (Courtesy of Betty Barrett Ripley.)

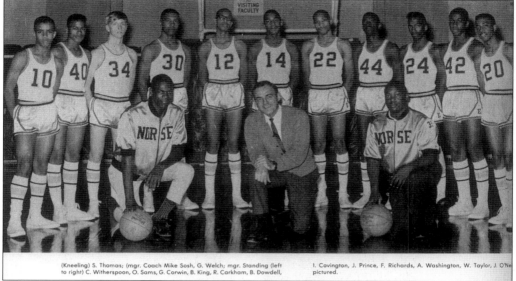

(Kneeling) S. Thomas; (mgr. Coach Mike Sosh, G. Welch; mgr. Standing (left to right) C. Witherspoon, O. Sams, G. Corwin, B. King, R. Carkham, B. Dowdell, I. Covington, J. Prince, F. Richards, A. Washington, W. Taylor, J. O'Ne pictured.

EHS BASKETBALL, 1967. Winning basketball returned to Emerson in the winter of 1966. Under the guidance of Coach Mike Sosh the Norsemen displayed hustle, teamwork, and a winning attitude. Pictured is the varsity team of 1967-1968. The team went 13-7 that year defeating Valparaiso and state-ranked Tolleston. (Courtesy of Calumet Regional Archives.)

EHS BOOSTER CLUB. School spirit did not just involve cheering for winning sports teams during the year. There were periods when athletic teams could not buy a victory and the student body was down in the dumps. To help the Gold and Grey keep its school pride, the Emerson Booster Club organized numerous events to foster a sense of community. Pictured are the members of the Emerson Booster Club of 1966-1967.

125

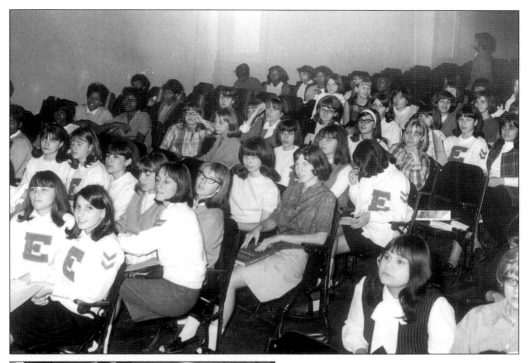

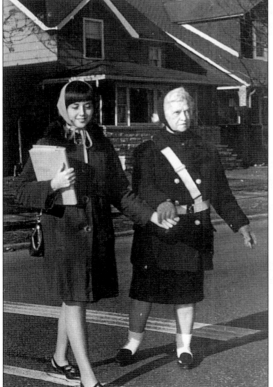

EHS GAA, 1966. Sports programs for girls were limited in scope before the 1980s, but schools did offer and sponsor activities for young ladies. The Girls Athletic Association, GAA, was organized much the same as boy's lettermen clubs. Pictured is a GAA meeting in the Emerson Auditorium in 1966. (Courtesy of Calumet Regional Archives.)

EHS CROSSING GUARD. For many years Mrs. Irene Lahaic was a familiar face at the intersection of Seventh Avenue and Virginia Street. She was the school crossing guard who made sure that students from St. Luke and Emerson schools were safe. Mrs. Lahaic was there every school day, regardless of the weather. She is pictured here in the mid-1960s. (Courtesy of Calumet Regional Archives.)

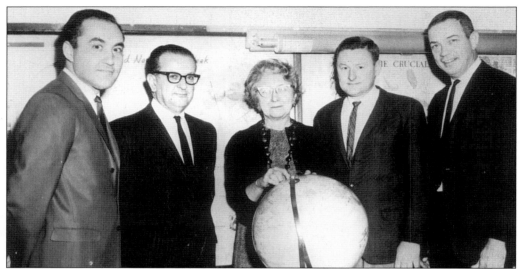

EHS HISTORY TEACHERS, 1965. It is sad, but history and government is of no interest to some students until they are adults. They have other interests in high school, not academics. Still, Emerson High School had some very dedicated Social Studies teachers. Pictured from left to right: Mr. Christ Christoff, Mr. Jerome Ziedman, Miss Hazel Grieger, Mr. Richard Wells, and Mr. Daniel McDivitt in 1965. (Courtesy of Calumet Regional Archives.)

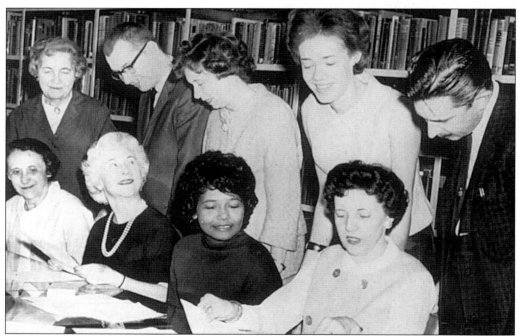

EHS ENGLISH TEACHERS, 1965. Members of the English Department get ready for the 1964-1965 school year at Emerson. Seated left to right: Mrs. Gladys Pierce, Miss Roma Anderson, Miss Mabel Bianchi, and Mrs. Arlene Von Horn. Standing: Mrs. Catherine Greenwald, Mr. Robert Glazier, Mrs. Gertrude Palmer, Miss Diana Blue, and Mr. Steve Parfenoff. (Courtesy of Calumet Regional Archives.)

KARL MALDEN, 1956. One of the most-famous graduates of Emerson High School was Karl Malden (Mladen Sekulovich). He became an actor who made numerous films and for a while co-starred with Michael Douglas in the TV series, *The Streets of San Francisco*. Recently he appeared in NBC's the *West Wing*. He is pictured here with his father, Peter, in 1956. (Courtesy of Calumet Regional Archives.)

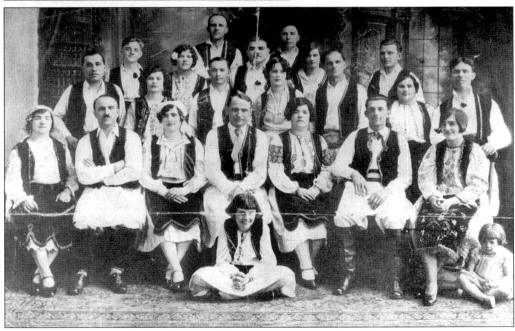

YOUNG KARL MALDEN. Even at an early age Karl Malden shared his many talents with the community. Here he appears with a Serbian dance and music group in 1927. He is standing in the third row at the left end. (Courtesy of Calumet Regional Archives.)

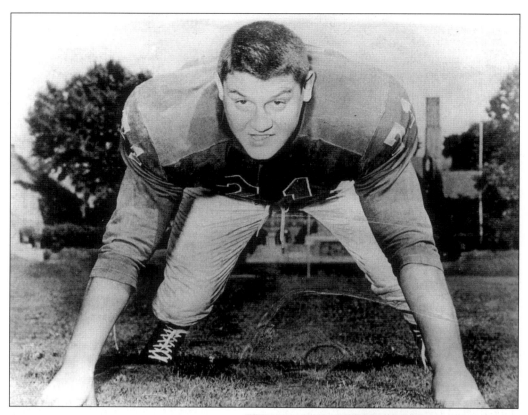

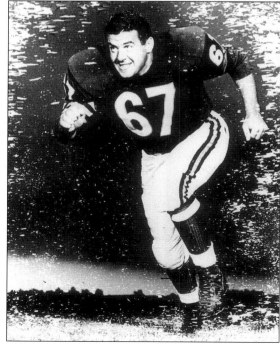

ALEX KARRAS. Emerson's Alex Karras had an outstanding career with the Detroit Lions of the NFL. When his playing days were over, Alex became a Hollywood actor and a commentator for ABC's Monday Night Football. Many fans still remember him as Mongo in Mel Brook's *Blazing Saddles*. (Courtesy of Calumet Regional Archives.)

TED KARRAS. Emerson grad Ted Karras played for the Chicago Bears of the NFL. He later served on the Gary City Council. Another brother, Lou, played for the Washington Redskins. (Courtesy of Calumet Regional Archives.)

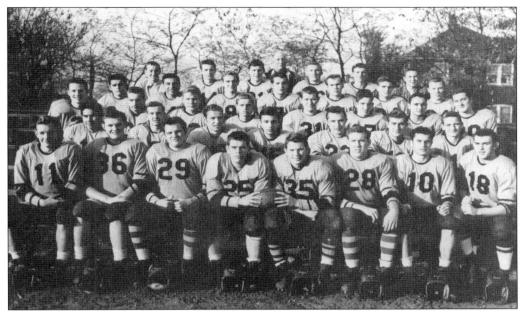

EHS FOOTBALL SQUAD, 1955. During the 1955 season, the Golden Tornado Football Team earned a share of the Northwest Indiana High School Championship. Coach Art Rolfe's squad rolled over traditional rivals Lew Wallace, Horace Mann, and Froebel. Paul Karras and Ken Callaway served as team co-captains. (Courtesy of Calumet Regional Archives.)

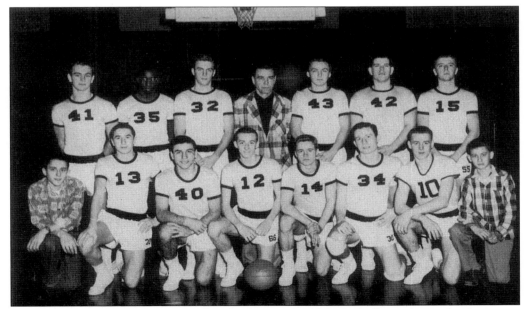

EHS BASKETBALL, 1954-55. Coach Bill Klug's 1954-55 Basketball squad pose for their team picture. Left to right, 1st row: B. Skalko, A. Castellani, G. Toneff, J. Blankenship, B. Bodnar, B. Sebring, R. Filson, J. Howell; 2nd row: G. Beleslin, A. Hamler, J. Reeves, Coach Klug, M. Molchan, K. Callaway, C. Crowe. (Courtesy of Calumet Regional Archives.)

120

EHS Prom, 1952. One of the big social events in the life of every high school student was the Prom. As the big event drew near young ladies and gentlemen went through a hectic time in getting the right dress, renting the proper tux, buying the matching flowers, and getting to use the family car. Of course, getting the date was most important! Pictured is Raymond Francis on his way to pick up his date for the Emerson Prom in 1952. (Courtesy of Raymond Francis.)

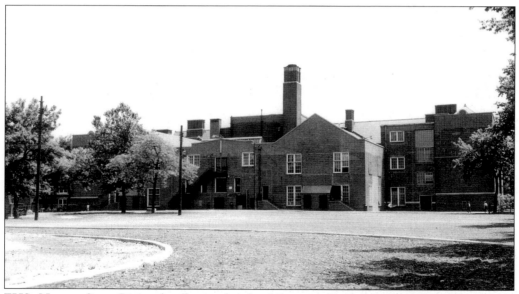

EHS, North Side. Pictured is the north side of Emerson High School in 1956. The section with the peaked roof was the boys' upper and lower gyms. Hidden behind the trees were the girls' gyms. The bank and choir rooms occupied the center area. If the viewer looks closely to the right, youngsters playing a game of strike out are visible. (Courtesy of Calumet Regional Archives.)

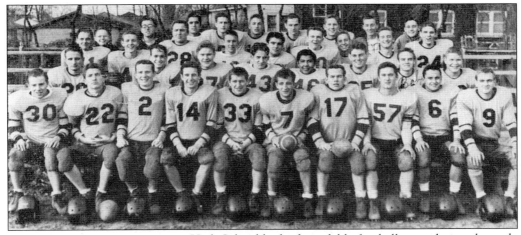

EHS FOOTBALL, 1954. Emerson High School had a formidable football team during the early 1950s. Pictured is the varsity team that went on to win 6 of 9 contests. The Golden Tornado defeated opponents such as Hobart, Lew Wallace, and Horace Mann in 1954. (Courtesy of Calumet Regional Archives.)

EHS COACHES AND CO-CAPTAINS. Coaching duties for the East Side squad of 1954 were handled by Art Rolfe and Harry Szulborski (standing). Team co-captains were Dave Aydelotte and Dan Mcleod. (Courtesy of Calumet Regional Archives.)

SINATRA CONCERT FOR EMERSON.
In September of 1945, some 800
students from Emerson High School
walked out in protest over the new
desegregation policy. To try to ease
tensions the Anselm Forum invited
Frank Sinatra to do a concert at
Memorial Auditorium on November
1st. During his performance the
singer urged students to return to
school. A quick solution did not take
place as the protesters remained out
until mid-November. (Courtesy of
Calumet Regional Archives.)

SINATRA CROWD. Sinatra was able
to draw a crowd of some 6,000
spectators. Most of the gatherers
were Bobbie-sockers who wanted to
see and hear "Mr. Blue Eyes." Many
had no interest in the protest or its
cause. (Courtesy of Calumet
Regional Archives.)

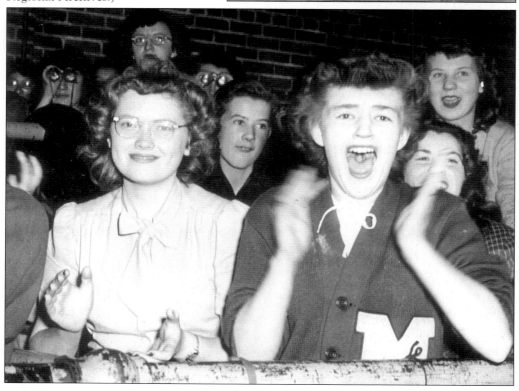

EHS Office Staff. Often overlooked at many schools were the ladies of the office staff. They made sure grades were processed, absentee records kept accurate, administrative paperwork complete, and a host of other bureaucratic functions were ready each day. Pictured is the 1940 office staff of Emerson High School. They were at left; Mrs. Jones, Miss Thomae, and Miss Hoffman; at center; Miss Chuba; and left; Mrs. Schoon, Miss Link, and Miss Beveridge. (Courtesy of Calumet Regional Archives.)

Emerson Sixth Grade, 1945. Emerson students had a great deal to be thankful for as Thanksgiving approached. The Second World War was over and many would be reunited with family members who answered the nation's call in the cause of freedom. The young lady in the second row, second from left proudly wears the dog tags of a family member. The picture is a group shot of the sixth grade class in November of 1945. (Courtesy of Raymond Francis.)

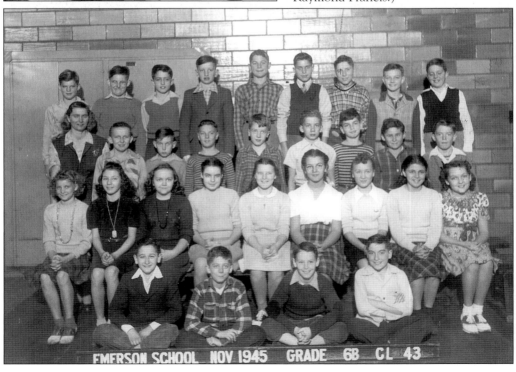

TEACHERS AND STUDENTS WHO SERVED IN WORLD WAR II

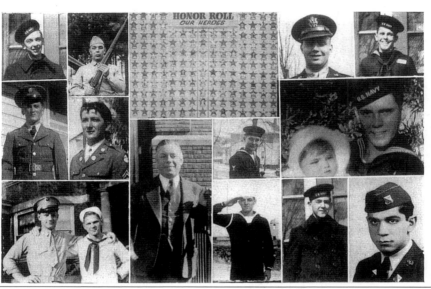

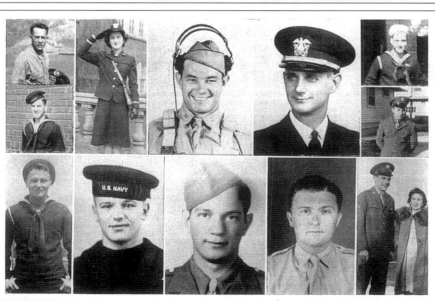

(Courtesy of John Peck; Class of 1943.)

IN MEMORIAM
COACH RALPH BRASAEMLE
OCTOBER 29, 1892 — MARCH 26, 1940

Memory gives continuity and dignity to human life. It holds us to our family and to our friends.

R. W. EMERSON

Only rarely does a school possess a teacher who can build in others such confidence in and respect for himself that everyone accepts his decisions without further question. Such a teacher was Ralph E. Brasaemle. May his long service for the Emerson School and his fine example inspire us to redouble our effort to fill as best we may the place he filled.

E. A. SPAULDING

We who had the privilege of working with him know his many virtues. He was a family man with loving kindness. His religion was one which he used every day. He was industrious — never shirking, even to the last. He has left his influence with hundreds who had the opportunity to work with him, or under him on his many teams. I shall ever prize the years I spent with him as a co-worker.

ARTHUR J. ROLFE

To Ralph Brasaemle, a man whose place it will be hard to fill; a man who spent his life building up and developing boys; a man whose sole aim was to make his boys sportsmen — win, lose, or draw; whose life was basketball; who was a second "Pop" to all his boys; to this man, we, the basketball boys, say to a grand fellow, "So long, 'Bras'."

ROBERT BOKICH, '40

It was one of "Bras'" happiest moments when one of his boys would stop and reminisce, and it made him even happier to be consulted whenever they were troubled. They knew in Bras, they had a sincere listener and a sure solution to their problems.

"Bras'" great charitable doings, known only to those that have felt the touch of his hand, the reassurance of his smile, and the strength of his character, could be compiled and fill a volume, rather than just a few lines in tribute.

God certainly blessed Emerson School by sending us this great man. Nothing I can say would be enough.

GEORGE GILEY, JR. '24

"Bras" was a quiet undemonstrative friend. He told you the truth even tho it hurt, and the effect of his admonishments was for a lifetime. There are thousands of his boys who will always remember the twinkle in his eye and that bit of a lisp in his speech with grateful affection.

GLENN REARICK, '20

Page Seventeen

COACH BRAS' MEMORIAM. In 1940, Emerson lost its basketball coach, the respected Ralph Brasaemle. A page of remembrance was placed in that year's school yearbook. (Courtesy of Calumet Regional Archives.)

114

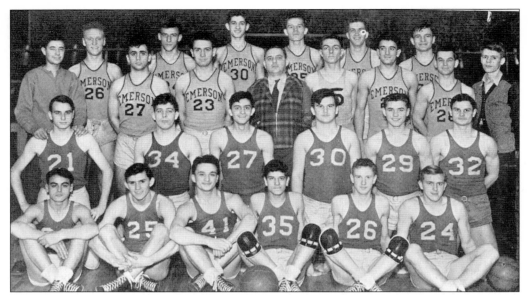

EHS BASKETBALL, 1938. Finishing the 1937-38 season with an excellent record of 19 wins and only 3 losses, the East Siders were stunned in the opening round of the basketball sectionals. The Valparaiso Vikings defeated the Emerson Norsemen 26 to 21. Pictured are Coach Ralph Brasaemle's varsity and reserve teams. (Courtesy of Calumet Regional Archives.)

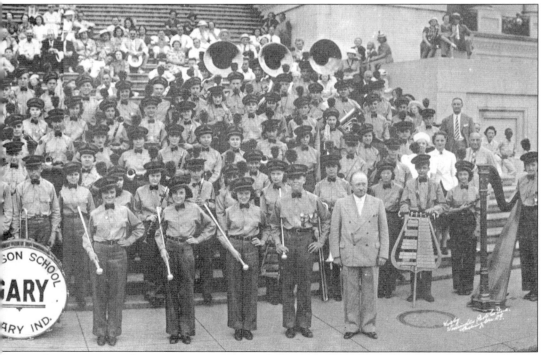

and parents pose for a group picture on the steps of the United States Capital Building. (Courtesy of Calumet Regional Archives.)

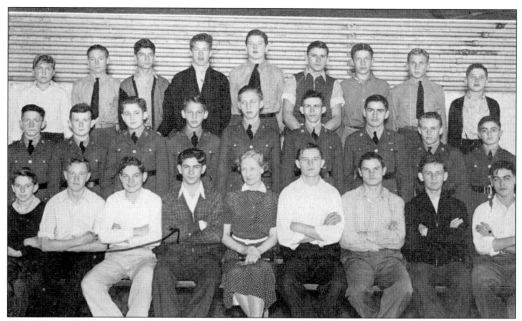

MISS PETER'S CLASS, 1938. Miss Peter's homeroom poses for a group shot in 1938. (Courtesy of Calumet Regional Archives.)

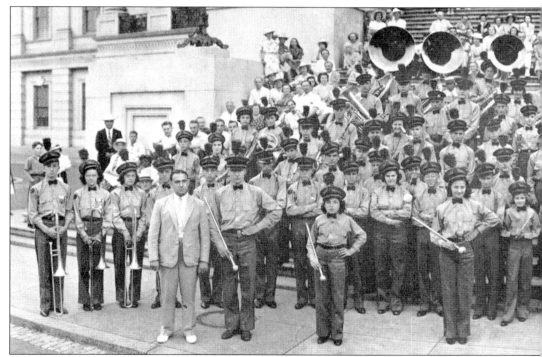

EHS BAND IN DC. School field trips to Washington D.C. have been popular excursions for teachers and students for generations. In 1938, the entire Emerson High School Band not only made the trek but also performed in the nation's capital. Here the band, directors, chaperones,

Nineteenth Annual
Commencement
1927

𝔈

Emerson High School

Gary, Indiana

Palace Theatre
Friday Morning, June twenty-four
Nine-thirty, a.m.

GRADUATION 1927. Before Memorial Auditorium held commencement exercises, Emerson High School held the grand event at the Palace Theater on Broadway. Notice that the ceremonies were at 9:30 a.m. (Courtesy of Calumet Regional Archives.)

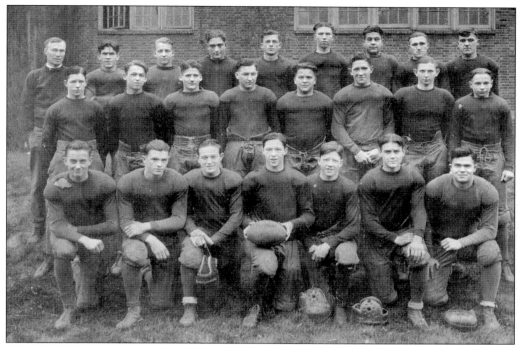

EHS 1924 STATE CHAMPIONS. Emerson High School once again emerged as Indiana's dominant football power by taking its third-straight state title. (Courtesy of Calumet Regional Archives.)

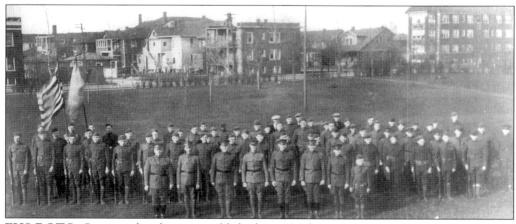

EHS ROTC. One popular elective established in 1920 for young men at Emerson, sophomore through senior years, was the Reserve Officer's Training Corps. Cadets were instructed in military history, the handling of weapons, first aid, and of course, drill. Afterschool activities included marksmanship and drill team competition against other Indiana ROTC high schools. Pictured is the 1923 ROTC class. (Courtesy of Calumet Regional Archives.)

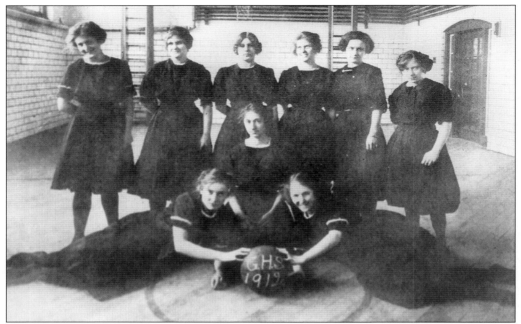

EHS Girls Basketball. Since its earliest days, Emerson High School offered athletic programs for boys and girls. Pictured is the 1919 Girls Basketball team. The team photo was taken in the girl's upper gym. (Courtesy of Calumet Regional Archives.)

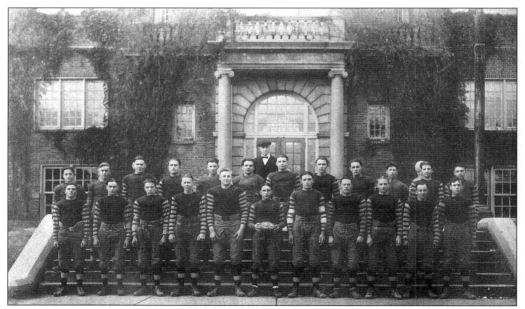

EHS 1922 State Champions. In the 1922 season, the Gold and Grey of Emerson High School won the Indiana State High School Championship. There was no playoff system in place but Coach George F. Veenker's squad earned the honor by outscoring opponents 427 to 0. They capped the season with a 33-0 defeat of the Warsaw Tigers. (Courtesy of Calumet Regional Archives.)

Emerson High School Wins Indiana Football Championship

STATE FOOTBALL TITLE WITHIN GRASP OF EMERSON

Emerson Crushes Whiting For Cage Crown

Emerson Beats Froebel For Three Grid Crown

Emerson Smears Elwood In High School Title Race

EMERSON SPORTS HEADLINES.
Newspaper headlines provided reminders of the success of Emerson's athletic teams during the 1920s. The Gold and Grey was a genuine football powerhouse in the state of Indiana. No facemasks or leather helmets were the order of the day. Most players played both ways, unlike the players of today. (Courtesy of Calumet Regional Archives.)

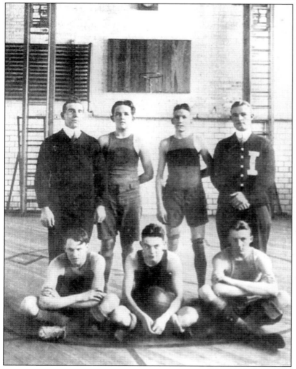

EHS BASKETBALL, 1919. It was a very different game of basketball in the early years of the 20th century. Set shots, defenses, and low scores were the rule. A 6-foot player was considered a big man. In 1913, Emerson, known as Gary High School, was runner up in the State Finals. In 1917, the Norsemen were eliminated by Lebanon in the first round in Indianapolis. Pictured is the 1919 squad with their coaches. (Courtesy of Calumet Regional Archives.)

BOYVILLE BAND. For those with musical talents or interest, a Boyville Band was organized at Emerson. Pictured with his musicians is Judge Willis Brown, Gary's own "Music Man" in front of the main entrance of Emerson School around 1911. Brown created a number of organizations to involve young men 10 to 18, including a band, Boyville government, and newspaper. (Courtesy of Calumet Regional Archives.)

EMERSON CAFETERIA. Most students were within walking distance of the Emerson campus so they went home for lunch. For those who were unable to leave, a cafeteria was located at the ground level of the main building. This old photograph shows the lunchroom around 1920. (Courtesy of Calumet Regional Archives.)

EMERSON POOL. Many of today's modern schools have Olympic sized pools for their students. The facilities are often open to the public during non-school hours. Though tiny by comparison, Emerson had the first indoor pool in the state of Indiana. Boys and girls swam on different days. Many young men from the school snuck into the shower room to watch when the girls swam. (Courtesy of Calumet Regional Archives.)

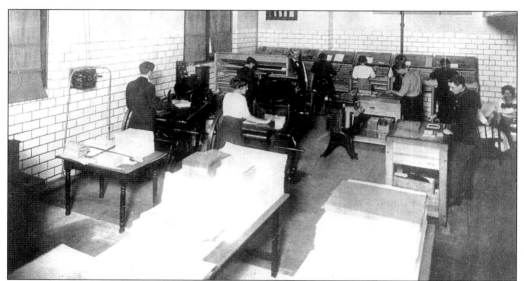

EMERSON YEARBOOK PRINTING. Before big publishing companies produced yearbooks, many schools printed their own. In 1913 Emerson students, with the guidance of their teacher, put together their own annual at the school. Modern technology was years away though. Young East Siders learned first hand how to meet deadlines, set type, print, and bind their books of memories. (Courtesy of Calumet Regional Archives.)

MR. SPAULDING. E.A. Spaulding served as Emerson School's first principal. For 40 years he was in charge of the East Side's public learning institution. He is pictured in 1914. (Courtesy of Calumet Regional Archives.)

COOKING CLASS, EMERSON. Emerson school helped prepare its students for life after graduation. In keeping with Dr. William Wirt's educational theme of work, study, and play, the East Side institution offered a diverse curriculum. Here, young ladies prepare for their Domestic Science class in 1910. (Courtesy of Calumet Regional Archives.)

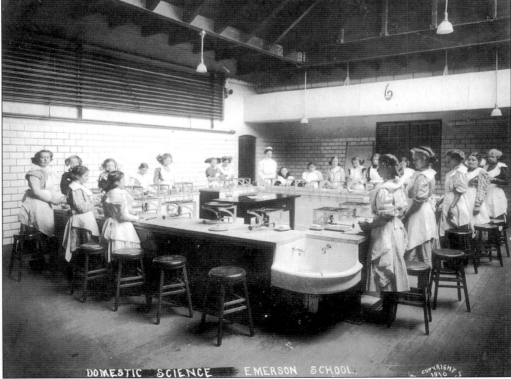

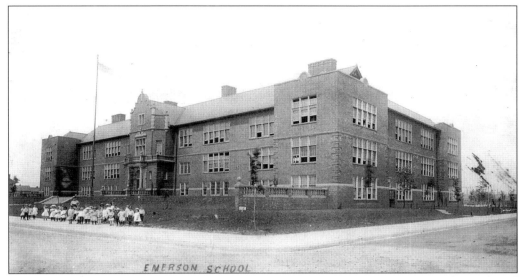

EMERSON COMPLETE, 1909. Once Emerson School was complete, the new faculty and staff embarked upon their educational mission. During the first half of the 20th century, the Gary School System became a model for academic excellence and innovative programs that helped provide a better-educated work force and responsible citizens. Pictured is the main building as it appeared around 1909. (Courtesy of Calumet Regional Archives.)

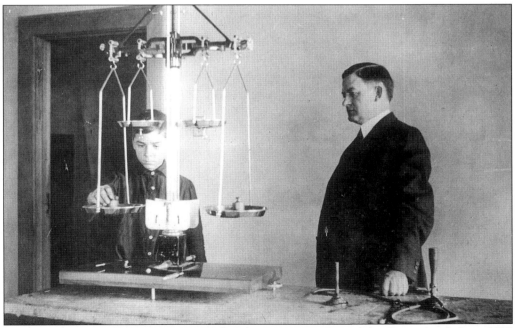

WILLIAM WIRT. William A. Wirt served as the Superintendent of the Gary schools from 1907 until his death in 1938. His system of work, study, and play was part of the curriculum at Emerson and other city schools. Teaching was departmentalized and students were provided labs, shops, gyms, and a host of after school activities. Time was even provided for religious activities. (Courtesy of Calumet Regional Archives.)

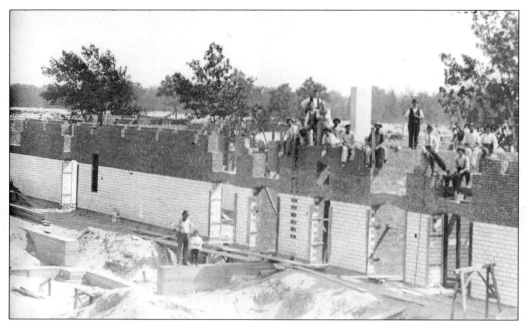

EMERSON CONSTRUCTION CREW. As more young families settled in Gary, new school construction was a priority. Here the construction crew poses for a picture while building the west wing of Emerson School in 1908. The educational facility still operates today as the Emerson School of the Performing Arts. (Courtesy of Calumet Regional Archives.)

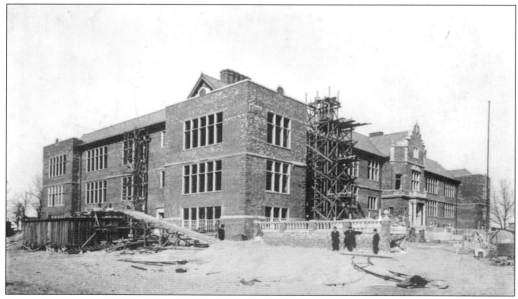

EMERSON CONSTRUCTION. Construction of the Steel City's first high school continued at a brisk pace. With most of the exterior work nearly complete crews turned their attention towards classrooms, labs, the gym, and auditorium. Nearly 100 years old, the East Side school was built to last. Even today maintenance workers marvel at the solid structure. (Courtesy of Calumet Regional Archives.)

Mr. Spaulding and Staff Members Discuss Ralph Waldo Emerson, Our Theme

William J. Flynn, a member of the first Gary Board of School Trustees, suggested that the first high school be named for Ralph Waldo Emerson, styled by a recent biographer as "the wisest great American."

Hail to the Gold and Gray

Hail to the Gold and Gray, colors of fame.

Truth and fidelity stand for your name.

Long may your valor last

After we're gone,

Shouting and praising dear old Emerson.

(Courtesy of Calumet Regional Archives.)

Six
EMERSON HIGH SCHOOL

In 1909, Emerson School opened and began classes for high school and elementary students that resided in Gary's East Side neighborhood. The curriculum followed the work, study, and play program designed by Dr. William A. Wirt, the city's first superintendent. Along with the traditional courses, the school provided science labs and shop classes, and offered students many extracurricular activities.

As the school population grew, a separate building was constructed for the shop classes in 1924. Four years later, a new elementary building opened. Emerson was the first school in Indiana to have an indoor pool, a modern auditorium, and even a zoo. The ROTC program, established after World War I, became a source of pride and patriotism. Its football program won six Indiana State Football Championships. From 1920 through 1926, the Golden Tornado went 55-2-6, including three consecutive football titles from 1922 to 1924. Not to be outdone, the 1927 Norsemen basketball squad, which finished 21-5, went on to the state tournament before falling to Martinsville.

Students displayed a special pride in their school. They were taught by dedicated teachers whose reputations were known throughout the East Side. And each senior class led and passed on that school pride to the underclassmen, pride in the Gold and Grey.

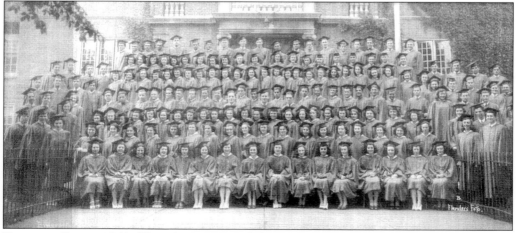

EMERSON CLASS, 1943. Their faces expressed the joy of countless graduates everywhere. They had completed four years of high school at 'dear old Emerson.' But soon many of the Class of 1943 would answer their nations call to duty and help win the deadliest war in the history of mankind. (Courtesy of John Peck Class of 1943.)

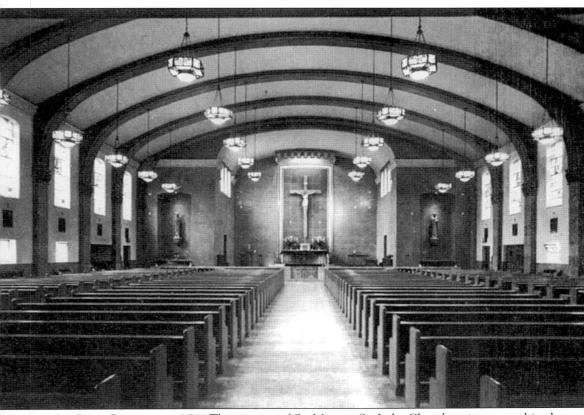

St. Luke Interior, 1970. The interior of St. Monica-St. Luke Church as it appeared in the 1970s. (Courtesy of Diane Trafny-Greenwood.)

AWARD FOR FATHER MARTIN. In 1978, the Rev. William Martin received the John F. Kennedy award at the Sons of Erin banquet. He was honored for his years of service to the Church and the community. Father Martin served St. Luke as assistant pastor then, a few years later, as administrator. He worked with the Catholic Youth Organization (CYO) and saw to the development of Camp Lawrence in Valparaiso, Indiana. (Courtesy of Gary CYO.)

SISTER M. JEROME
MANOSKI S.SP.S.
(Michelle Manoski)

SISTER ANDREA
SULLIVAN, PHJC. (Kathy
Sullivan) (Courtesy of
Diane Trafny-Greenwood.)

FATHER MARTIN.
Rev. William L.
Martin, pictured here
during his days as
Assistant Pastor of St.
Luke, gave many
years of dedicated
service to the East
Side parish. Father
Martin today resides
in Michigan City,
Indiana, and keeps in
touch with many
from the old East
Side community.
(Courtesy of Diane
Trafny-Greenwood.)

FATHER MORALES. Rev. Monsignor
John F. Morales was appointed pastor
of St. Luke Parish following the
sudden death of Father Henry
Ameling. In 1972, Father Morales
was sent to St. Mark Parish in Glen
Park. Father Seraph Menello took
over the duties as pastor of St. Luke.
Father Morales resides in California
today. (Courtesy of Monsignor John
Morales.)